valencia

© **TRIANGLE POSTALS SL, 2010**

Photographs **RICARD PLA:** 4, 6, 14, 16, 17, 18, 20,21,24, 28,29, 30, 31, 32, 33, 35, 37, 44, 45, 48, 53, 54, 56, 58, 62, 64, 65, 67, 69, 70, 73, 77, 78, 81, 83, 84, 86, 89, 90, 91, 93, 95, 96,97, 98, 99, 101, 102, 103, 110, 112, 114, 115, 116, 120, 121, 124, 126, 127, 128, 129, 130, 131 132, 133, 139, 140, 143, 146, 147, 148, 149, 150, 151, 154, 158, 160, 161, 164, 175, 188, 194, 196, 198, 203, 209, 217, 224, 227, 230b, 234, 240 **RAFA PÉREZ:** cover, 39, 40, 41, 42, 46, 47, 49, 59, 60, 72, 76, 79, 80, 88, 104, 106, 108, 109, 113, 117, 118, 119, 125, 169, 170, 171, 172, 195, 201, 206, 218, 219, 220 **LUCAS VALLECILLOS:** 12, 27, 52, 75, 105(acd), 107, 138, 168, 173, 178, 182, 184, 187, 191a, 193, 211
JOAN M. LINARES: 19, 22, 23, 51, 55, 57, 63, 71, 74, 85, 94, 122, 136, 141, 229, 235, 238 **KAI FOSTERLING:** 155, 156, 167, 177, 228, 230a, 232, 237 **JAVIER YAYA:** 205, 208 210, 213, 214, 215, 216, 222 **PERE VIVAS:** 100, 142, 144, 145, 152 **LAIA MORENO:** 105b, 123, 179, 180, 181, flap **MATEO GAMÓN:** 9, 159, 162, 163 **NICOLAS RANDALL:** 25, 189, 191b **MIGUEL RAURICH:** 190 **JAUME SERRAT:** 197 **TINO SORIANO:** 174

Text **JAIME MILLÁS**

Translation **BABYL TRADUCCIONES**

Design **JOAN BARJAU**

Printed by **TECFA**

Reg. number B-30502-2010

ISBN 978-84-8478-194-3

Acknowledgements to: AYUNTAMIENTO DE VALENCIA • IVAM, INSTITUT VALENCIÀ D'ART MODERN • MUVIM, MUSEU VALENCIÀ DE LA IL·LUSTRACIÓ I DE LA MODERNITAT • MUSEO NACIONAL DE CERÁMICA Y DE LAS ARTES SUNTUARIAS "GONZÁLEZ MARTÍ" • JARDÍ BOTÀNIC DE LA UNIVERSITAT DE VALÈNCIA • CIUDAD DE LAS ARTES Y LAS CIENCIAS

TRIANGLE POSTALS, SL
Carrer Pere Tudurí, 8 • 07710 Sant Lluís, Menorca
Tel. +34 971 150 451 / +34 932 187 7 37 • Fax +34 971 151 836
www.triangle.cat

valencia

Text
JAIME MILLÁS

Photographs
RICARD PLA | RAFA PÉREZ | LUCAS VALLECILLOS | JOAN M. LINARES | KAI FOSTERLING
JAVIER YAYA | LAIA MORENO | PERE VIVAS | MATEO GAMÓN | NICOLAS RANDALL
MIGUEL RAURICH | JAUME SERRAT | TINO SORIANO

TRIANGLE ▼ POSTALS

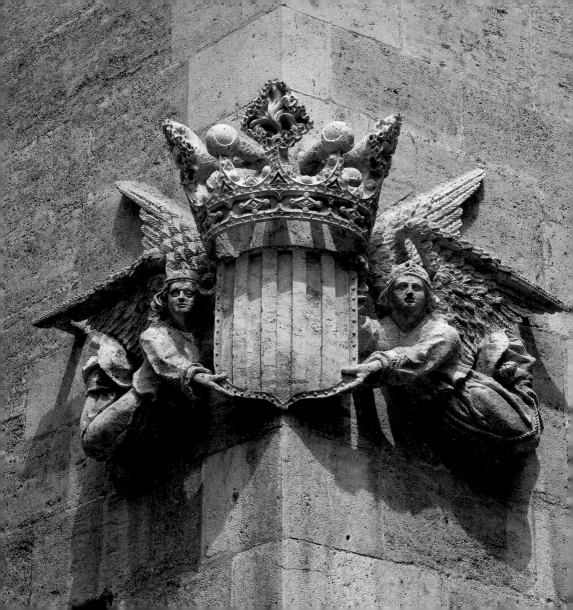

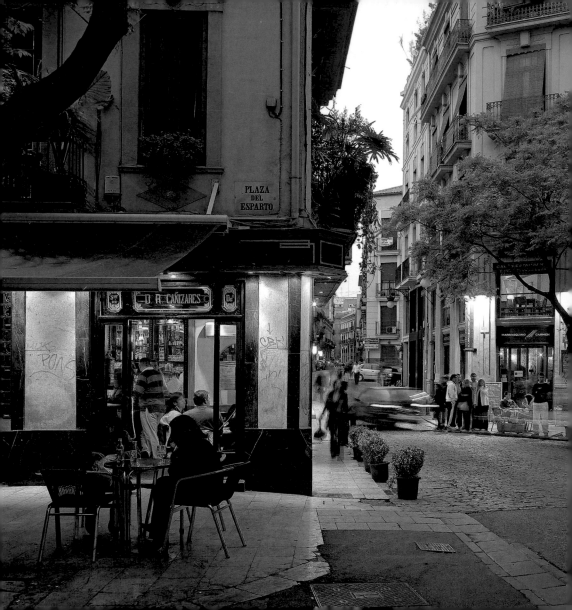

A mediterranean city

Valentia was founded by Roman colonists in 138BC, on a small island in a branch of the river Turia. Strategically located on the Vía Augusta, the commercial and military route which united the Imperial Capital of Rome with Cadiz, this urban enclave provided its new occupants with fertile lands which, being close to the Mediterranean and an abundance of natural water, were easily extendible. Added to this was the possibility of connecting with the peninsula's southern and interior routes and the extensive coastal territories to be occupied, as well as being close to the then important Roman nucleus of Saguntum.

The influence of Romanisation was a decisive element in the city's development, that is until the start of its decline and Germanic invasions brought further devastation to the already falling empire.

After the Visigoths came and went, not without leaving their mark on the city, Valencia began a long, influential period of occupation under the Moors who initiated their pacific invasion of this territory in 718 and remained until, in 1238, the city of Valencia was conquered by the Christians. Whilst there remains little in the way of any monumental vestiges of Islam, the traditions have been well preserved in irrigation and agricultural systems, gastronomy, philosophy and way of life, as well as the urban distribution and place names.

The Moorish city remained tolerant of both Christians and Jews, allowing them to preserve their own language and religion. The city's expansion, marked as it was by the notable power of the Kingdom of Cordoba, brought about a growth in the city of each of the three cultures. With the creation of the independent Muslim kingdoms in the Iberian Peninsula, the Moorish influence soon become fragmented and debilitated. Valencia became a prime target for renewed attacks from the Castilian Christians, a time in which the city lived through the double episode of being re-conquered in 1093 by El Cid, the legendary knight who chose this as the place to put an end to his exile from Castile, and nine years later Valencia fell once again into the hands of the Almoravid Moors.

After the conquest of Majorca, an island off the coast of Valencia, the King of Aragon, Jaime I, came to Valencia on the 9th October 1238 and made the city the capital of a kingdom, which was to come under the Crown of Aragon but would have its own autonomous parliament and laws. This king established the political and social basis of the city in such a way that, some time later, during the 15th century, Valencia was to become the main capital of the European Mediterranean, with a significant demography and economic activity, an unquestionable political influence and a notable presence in the development of the arts and writing. This century of gothic splendour has left an impressive mark on the city, an architectural heritage just waiting to be discovered in numerous postcard like urban settings similar to those of other Mediterranean cities not a million miles away, in Spain and Italy.

With the Renaissance period, Europe's political powers were transferred to Italy and Valencia fell into economic decline, exacerbated by the social uprisings against the city's monarchy and nobles.

It wasn't until the end of the 19th century that the city of Turia returned to play the leading role in what was to be a period of growth and social prominence. After what was to be the medieval city's golden age and another long historically mediocre period, this sequence was finally to change for the better with the arrival of industrialisation, the exportation of citrus fruits, the people of Valencia's appreciation for their own language and tra-

The Salón de Cortes evokes of those important citizens who practiced old style democracy in what was once the old Kingdom of Valencia

8

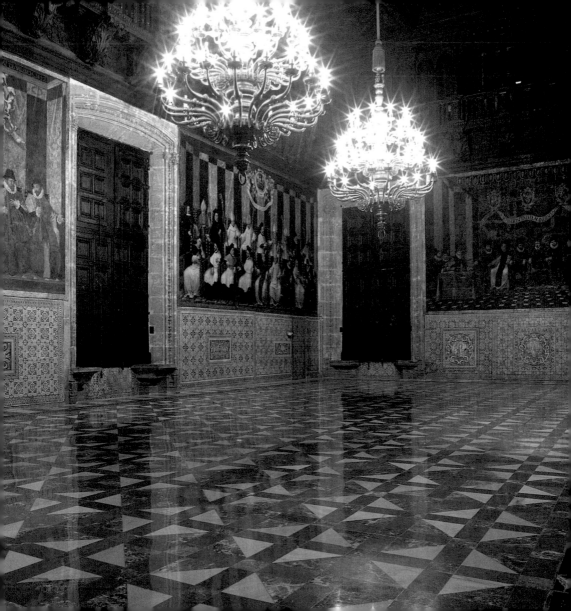

10 ❦ *Etching by A. Guesdon, A bird's eye view of Valencia, from 1858. Archive Huguet-Collection L. Giménez Lorente*

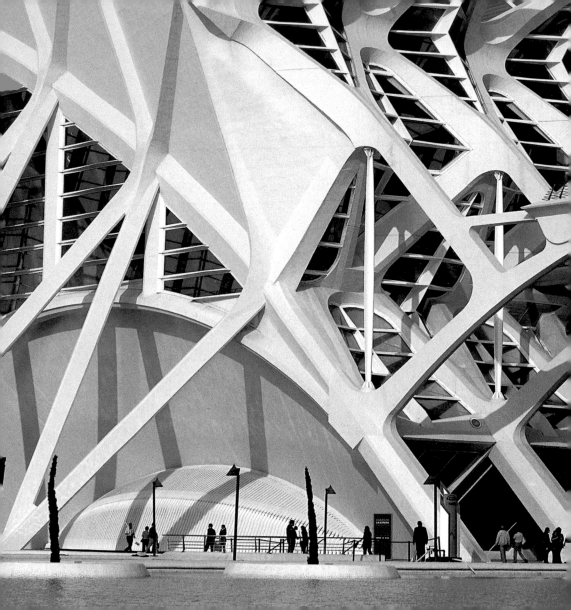

ditions and the desire to demolish the city's wall to make way for the city's expansion. In many cases the origins behind present day city planning lies in the styles and technical materials from Modernism times.

In 1957 the city had the misfortune to be affected by a tragic flood caused by the waters of the river Turia breaking it banks and flooding the city, leaving the city once again in a state of devastation. But as we all know, where there's collective misfortune the strength to overcome that misfortune always rises to the fore. As a consequence the so called Plan Sur was created to ensure the city would never again be devastated by the river, its former bed now filled with trees, flowers and sports facilities.

It is precisely this old river bed that has provided the foundations for the new millennium city. La Ciudad de las Artes y las Ciencias has its share of this renewed challenge to put Valencia in the wake of the world's greatest urban projects designed by Valencian architect Santiago Calatrava, whose first academic qualifications came from this city. This capital has likewise shown itself to be clearly committed to being a city of opportunities for the most innovative researchers who are currently revolutionising the field of biomedicine.

The outcome of this story is that the people of Valencia are an open-minded, typically Mediterranean and cosmopolitan population, suitably well-integrated by the events which have taken place over the years, albeit marked as they are by very different agendas, including at times, conflicts. Taking a look around this city, visitors can to see for themselves the vestiges of many different cultures and from which we can learn that the life of a city stems not only from its challenges but also its unspeakable wretchedness. This city's changing image has in the last few years come to replace its more traditional picture postcard image. If in the old days it was the gothic Torre del Micalet, now it is the monumental leisure and science city created by Calatrava.

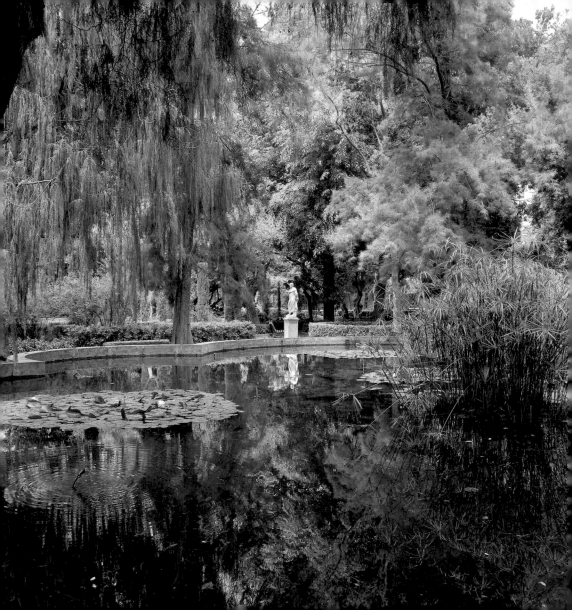

Green Valencia
the land of flowers

Of the Arabic society which lived in these lands for almost five centuries there remains practically no architectural testimonies, the materials used in their construction generally having been used in new buildings constructed by the Christians in the Middle Ages. However, what no one has been able to eliminate from the Valencian mentality is its love for water and the satisfaction of growing crops and creating gardens, aspects of daily life which the Arabs revealed in their literary works.

Ibn Gálib, a poet who lived in Ruzafa, a slum district outside the city walls, invited strangers in the 12th century to make a stop in the city to quench their thirst, since "it won't be long before the rain comes. Ask for water in Ruzafa and it is sure to rain in Ruzafa. There is no other land like this, covered with plants all laden with flowers like gold and silver".

The Christians who colonised these lands in the 13th century were convinced they were coming to a fertile land. The author of the historic chanson de geste Mío Cid also spoke of the fertility of these lands just before the historic knight was about to conquer the city. More contemporary travellers who come to this corner of the Mediterranean often feel the same way, influenced as they are by topics cultivated by Valencia's projected tourism.

If we recognise that the garden is in some ways a piece of nature which has been domesticated, rather like a piece of land enclosed within the privacy of an artificially arranged space, Valencia has a dozen excellent public gardens. Speaking in broader terms, here in Valencia we have the benefit of extensive green zones, united by urban tree-lined arteries, added to which we now have the river transformed into a lengthy garden which fills the city with the aroma of flowers and shade from the

trees. Three more spacious green zones are to be enjoyed in and around the capital, distributed in pairs, L'Albufera park with its corresponding El Saler beach, the nearby Sierra de la Calderona and the metropolitan forest park located next to the Turia, in Paterna on the outskirts of the city and finally the Ribarroja and the La Eliana.

It was the Arabs who in the 4th century first established the basis for the gardens by introducing cultivated species such as orange and lemon trees, palms and pomegranates and combined them with oriental flowers and plants such as cypress trees, myrtle, carnation and rose bushes. The Arabic-Valencian garden was characterized by a squared distribution, partitioned by hedges and an abundance of highly perfumed flowers such as myrtle and jasmine, their aromas mixed with orange blossom. To this we can add the gentle climate with its mild temperatures and humidity, the traveller's fascination for Valencia not difficult to explain when we consider their high expectations are the result of real life experiences.

Inside the Jardines del Real are the municipal nurseries

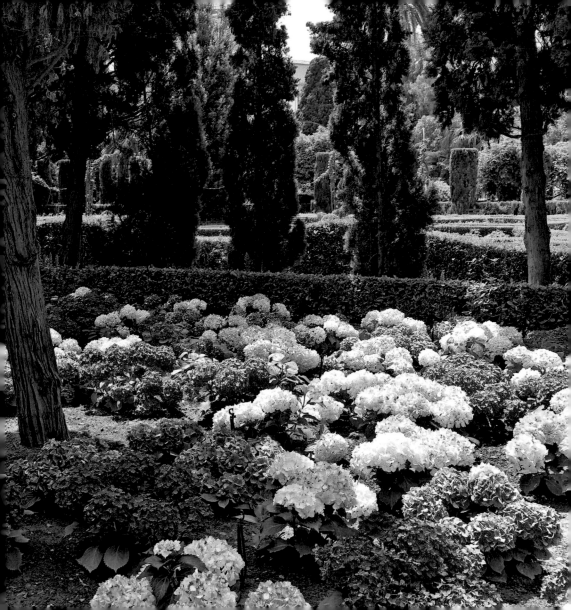

L'Albufera

L'Albufera, the nature reserve to the south of the city, begins on crossing the mouth of the new Turia and finishes practically at the foot of mount Cullera. This is actually an extensively used agricultural zone which balances its traditional fishing and agricultural pace with the constant presence of locals and tourists within its abundance of beaches and restaurants.

This park has always been considered a royal heritage site for its extraordinary natural beauty and its excellent wild duck hunting grounds and angling. This privilege was brought to an end in 1865 when the municipality successfully reclaimed the park to add to its own heritage. Besides the hunting and fishing, activities now in recession, L'Albufera is basically a huge flood plain filled with rice fields. Its fresh water supply comes from various inland springs (ullals) which permanently supply the lake and the park is connected to the sea by three channels with floodgates which regulate the level of water in the fields. The centre of the lake is called "lluent" being the spot where the waters appear to glisten the most. Arabic poets described it as the mirror of the sun.

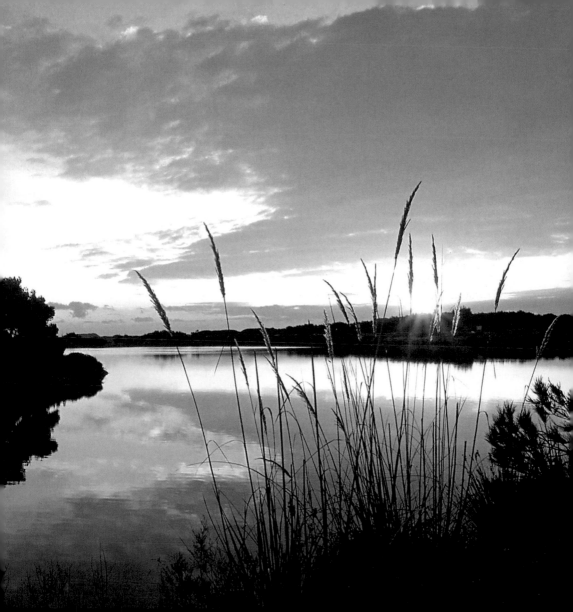

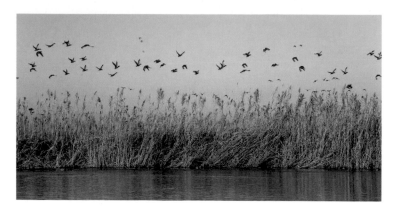

This area constitutes a natural paradise for migratory birds which each year journey from the cold northern hemisphere to the warm south. All manner of species migrate via this Mediterranean route, closely observed by the parks research centre, there also being a recuperation area for birds whose journey has been interrupted by illness.

The long coastal stretch of sandy beaches and pine groves between the dunes and malladas go by the names of Pinedo, El Saler and La Devesa. With close to a dozen kilometres of coastline, interrupted only by the water canals, this is a privileged beach spot in which to enjoy the sun and take to the water without there being an excessive concentration of bathers.

The fishermen's traditional way of life is particularly evident in the village of El Palmar, an island in the centre of the lake, which at the present time is well and truly united to terra firma. From the site of the park's main viewing point, located on the coastal road next to the first canal, boats can be hired to navigate the waters of the lake and its numerous canals. In former times the sail boats which ploughed through these waters sported a splendid Lateen rig. El Palmar is also a highly recommended place in which to enjoy a real Valencian paella as well as other fish and seafood delicacies.

Rice first came to the Mediterranean coasts from India as a result of Alejandro Magno's expeditions in the 3rd century B.C. It was first introduced to this nature reserve by the Arabs, originally on the edge of the lake which then belonged to the town of Sueca, in the Camp de Brahamons, a name of Hindu origin. Rice cultivation in Valencia, despite its unquestionable nutritional value, has passed through various phases of both prohibition and authorisation. The prohibition of rice was based on the fact that the wetlands in which it was cultivated were the cause of malaria and other epidemics. In fact rice cultivation wasn't actually permitted until 1986 having been awaiting authorisation for a number of centuries.

Rice cultivation and it cycle is explored in the Cullera rice museum. Between May and June the land is prepared to sow the seeds, after which the fields are filled with water which remains until September, to be emptied in preparation for harvesting. At times the fields are often inundated again from October to January to accommodate the needs of the duck game reserve.

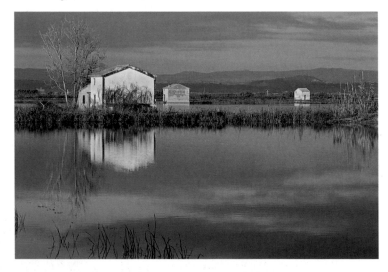

In summer the rice fields of L'Albufera glisten like mirrors of water

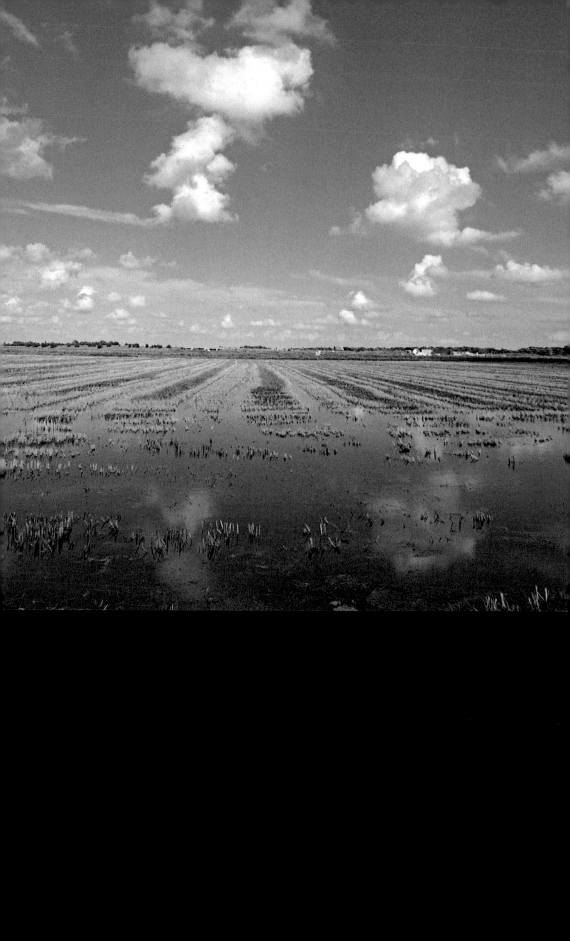

Only a tenth of the 30,000 hectares of lake spoke of by Roman chroniclers Avieno and Estrabón remains navigable. Since that time the park has been gradually transformed into marshland for rice cultivation. The 21,000 hectares are made up of thirteen districts which between them manage the nature reserve dependent on Valencia's local government. This area was declared a nature reserve in 1986, the first to be approved by the Valencian government.

City gardens

These originally Arabic influenced gardens, were subjected to dramatic changes when Italy and France began to leave their mark on Valencian customs. The formerly fertile lands now became subject to the use of perspectives and the play on light and shadow accompanied by sculptures and exotic flowers. Architectural features eventually became more important than the landscape.

The municipal jardines del Real, or royal gardens, also known as Viveros, are the most emblematic in Valencia on account of their history and design. They were originally created for the use and pleasure of the Muslim kings and later the Christian kings. Located on the opposite side of the river, therefore outside the city's walled limits, they were chosen by the monarchs as the construction site for their royal residence, in a palace of which there now remains no trace. Palace life came to be no more than a memory when the Palacio del Real was destroyed by the city's inhabitants in an episode during the War of Independence.

These gardens have provided the city with flowers and trees for many decades. The entrance nearest to the old river bed is marked by enormous palm trees and Mediterranean flora. A pond is filled with romantic swans and ducks, whilst in another section the façades of a baroque church and a noble's palace have been integrated within the park as if they were sculptures amongst the trees. The most modern section corresponds to the spacious lawns and rose beds. Also worthy of mention are the intimate little spots created between the neoclassic hedges and the sculpture by Valencian artist Andreu Alfaro, which takes pride of place amongst the avenue of cypress trees. Also included within the Viveros park complex are the Museo de Ciencias Naturales and the Zoo.

The old course of the river Turia is one of the most popular routes for those on a cycling tour of the city, free of road traffic and a variety of green zones along the way

For those with a liking for the exotica, the Botánico is the garden to see, part of the Universitat de València. Originally a fruit and vegetable garden used as an aid to teaching botany. The garden's present day layout created by naturalist Antonio José Cavanilles in 1802 was originally used for experimental cultivation and the acclimatisation of hitherto unknown species. A splendid cast iron and glass stove protects the tropical garden from the fluctuations in temperature.

The nearby jardín de las Hespérides has now been opened and in which there is a collection of fifty different varieties of citrus fruits. Another recently inaugurated garden, very close to the Palacio de Congresos has literary connections. The jardín de Polifilo, as it is known takes its inspiration from Sueños de Polifilo, the author of which is Francesco de Coloma. Of a particularly romantic nature the visitor can amble through the Puertas del Destino plaza to find the Guardián de los Huertos and pay a visit to the Isla de Ciretea.

Jardín de las Hespérides

The Jardín Botánico

30 *The Jardín Botánico, is the oldest in the city with 3,000 different species and more than 7,000 shrub and tree varieties*

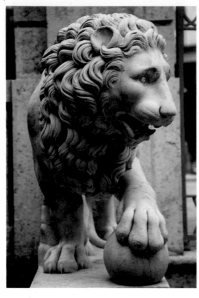

The agricultural land which was the origins of the jardines de Monforte was acquired by the marquis of San Juan in 1849 to be later transformed into a garden zone of Italian influence, adding considerable prestige to his illustrious mansion. The garden's inner section boasted two Carrara marble lions, the work of José Bellver. Just some of the features enclosed within this spectacular garden include a rather rococo like group sculpture and a fountain set in the centre of the glorieta, a pond overlooked by a Renaissance doorway, a long passage covered in dense bougainvillea and a mini forest of dense leafy trees.

The Glorieta, situated on the city's inner ring road, ceased to be enclosed when its artistic grille was installed in los Vivero. It was created in 1817 by Francisco Javier Elio, Valencia's French minded general. This garden boasts the most beautiful, that is not to say the largest, rubber plants in the city: the span at the top of the largest specimen being 40 metres in diameter. Also included in this garden is the Parterre or flowerbeds, in the centre of which rises the monumental statue of King Jaime I, promoter and creator of the former kingdom of Valencia. The trees which remain standing are truly amazing. The list of Valencia's parks and gardens is completed by those of Benicalap y Oeste and that of Ayora. In the future, when the Estación del Norte railway station has been transferred underground, the old platform and the present conglomeration of tracks will be transformed into the great Central park, by far the largest in the city, after the Jardín del Turia.

The pond in the jardines de Monforte and the staircase leading to a Renaissance entrance is the setting most popularly sought by newly-weds and protocol events

The old course of the River Turia

Along a winding route, marked by the final meanders before reaching the sea, the old River Turia provided natural protection for centuries to the population of Valencia. The Roman colony, the origin of the city, was founded on a fluvial island, more related to the orchard crops than with maritime trade. The Romans, however, created a small port on the river, in the historic centre where today stand the Torres de Serranos, before reaching the coast.

This geographical protection of the city had its negative aspects as well. The presence so close to the river constituted the main threat and origin of destruction of the large orchard that the waters themselves had made grow, because on being a typical Mediterranean river it always had a very irregular flow and, therefore, many floods. In more recent times the Turia in reality did not go through Valencia, because when it reached the city it carried practically no water, its flow had been exhausted in irrigation and urban supplies before reaching its mouth. This has nothing in common with this description by the botanist Cavanilles in 1795: "the floods are always frightening here, because nothing stops the waters from pouring towards the orchards, but if they occur when the riverbed is full when the wood that from Santa Cruz and Moya comes downriver to supply the capital, then the damage is incalculable". It has been a long, long time since the river was the natural way to bring down the wood to be manufactured in the capital.

In 1957 the City Council made a decision after the tragic flood of October and planned to reroute the river from the centre of the city by means of what was called the South Plan, a project that also enabled an improvement in the traffic with the construction of ring roads along the new riverbanks. On their first visit to Valencia during the democratic transition, the King and Queen of Spain presented the city with the riverbed as a whole, nine kilometres long and 150 metres wide, so that the lives of the people of Valencia would gain in quality and safety. Thus, by surprise, the city, which was already famous for

Paseo de la Alameda runs along the left bank of the river and originally was an access route to the Palacio Real. The start of the paseo is indicated by two fountains

being a land of gardens and flowers, found itself with one million square metres of new parkland for public use.

There were development-minded technocrats who for years considered the possibility of new roads on the inside of the dried-up riverbed of the Turia, but in the end the public opinion and the ecologist voice fought for and won its full use as parkland and leisure area. This was one of the grand projects of Valencia in the second half of the 20th century.

The old riverbed has been transformed into the backbone of the city, on the route that gives public life to its different neighbourhoods and districts on the right and left. As a green space and a large sports complex, the possibility of enjoying a permanent infrastructure of leisure and outdoor life has been afforded all these districts, an urban alternative that they had previously lacked.

The City Council offered the Catalan architect Ricardo Bofill the possibility of presenting a general occupation project of the riverbed to meet the great expectations created among the public, but finally his technical collaboration was focused exclusively on the closer, neoclassical setting at the Palau de la Música, and the ideas for other sections were covered by other specialists. In the urban design, Valencian architects from the Vetges Tu and Mediterrània studios were involved. It can be stated that the selective urbanisation of the old Turia has been completed gradually, in a staggered way.

The last parts in which he has been involved correspond to the more inland sections, to create the new Parc de Capçalera and Bioparc, and on the opposite side close to the mouth of the river with the development of the Ciudad de las Artes y las Ciencias. All that remains today is to urbanise the final part of the riverbed, which goes as far as the Port. The banks in this area are still freeing themselves of their old links to the industrial and port uses. The infrastructures produced for the Formula 1 competitions have aided in this and the City Council promotes tenders for projects to regenerate definitively the old mouth of the river with emblematic buildings, gardens and new avenues.

The water and the wood that the Turia dragged along for centuries no longer exist and their space has been occupied by parkland, leisure and sports facilities. Culture with a capital "C" also has a presence, because the urban route that establishes its old bed enables one to discover to the right and left a highly stimulating choice of cultural spaces. Today it is a river of culture and public gathering.

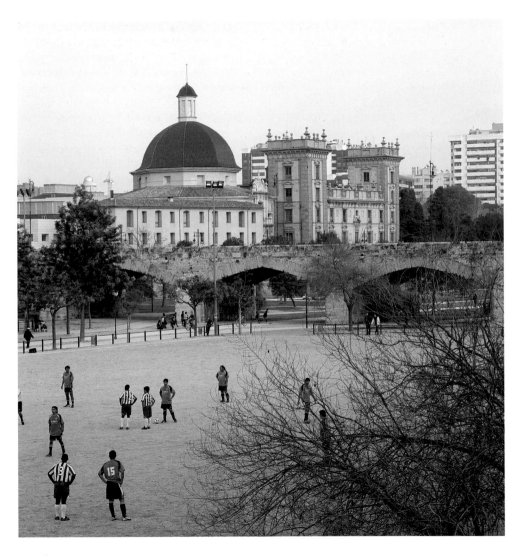

37 ◦ *Sports area in the old riverbed of the Turia*

Gardens and leisure spaces

The Parc de Capçalera starts, as its name indicates (head), the long river of parkland that the old Turia has become. Recently created, with a surface area of 150,000 square metres, a fifth part occupied by a boating lake, it recalls the area where the river changed its torrential course to become a pleasant lake. From a mountain-viewpoint one can take in this green space, also fitted out for cyclists.

The new zoological park of Valencia, Bioparc, is also located at this point. More than 100,000 square metres enable the visitor to move to the heart of Africa and live alongside, by immersion, the most characteristic animals and plant life of the savannah, equatorial Africa and Madagascar. There are no cages. The barriers between animals and visitors are almost non-existent, which gives off a feeling of being in an authentic habitat. Lions, hyenas, gorillas, giraffes, hippopotami, rhinoceroses, leopards, elephants and ostriches live in Bioparc as if they were in their natural environment.

Following the route of the old river towards the mouth, the Athletics Stadium provides excellent sports facilities. The section of the Turia garden, in front of the San José bridge, is treated as an urban forest park because it includes tree species from different counties as well as aromatic and medicinal plants. In this area, on the right bank is the hundred-year-old Botanical Gardens and Garden of the Hesperides. Rugby, baseball, football are just some of the sports played between the bridges of Sant Josep and Exposició.

The regular occupants of the river are the many spectators of competitions, cyclists, walkers, athletes and people the fresh air of this immense urban space. The section situated alongside the Paseo de la Alameda has been given over to the seasonal installation of fairs and marquees. It is also reserved for the vibrant nights of castles of fireworks. The nearby and popular gardens of Viveros and Monforte really must be visited.

Parc de Capçalera

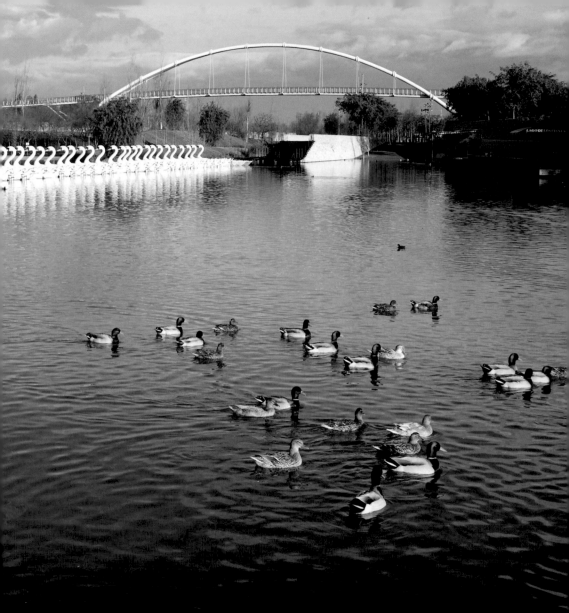

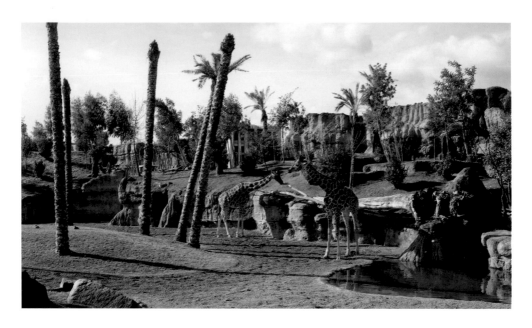

This green and sporting route continues along the neo-classical spaces designed by the architect Ricardo Bofill: cypresses, palms and pines, trees planted between ponds, anchored in the roots and between columns of classical culture. The large glass vault of the Palau de la Música increases the spectacular nature of the setting.

In the new gardens created around the Ciutat de Calatrava the city spreads towards the horizon of the Mediterranean Sea. A small train enables the route to be covered with little effort while one can admire the monumental character of the whole area.

In the new zoo of Valencia there are no cages. Lions, hyenas, gorillas, giraffes, hippopotami, rhinoceroses, leopards, elephants, ostriches... all live In Bioparc as If they were in their natural habitat.

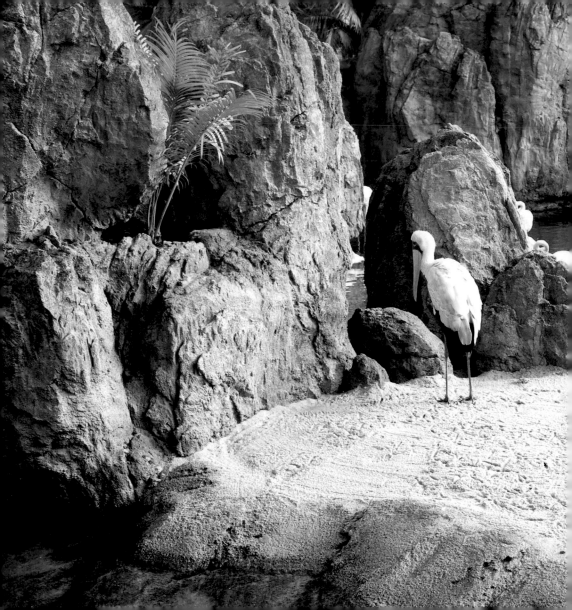

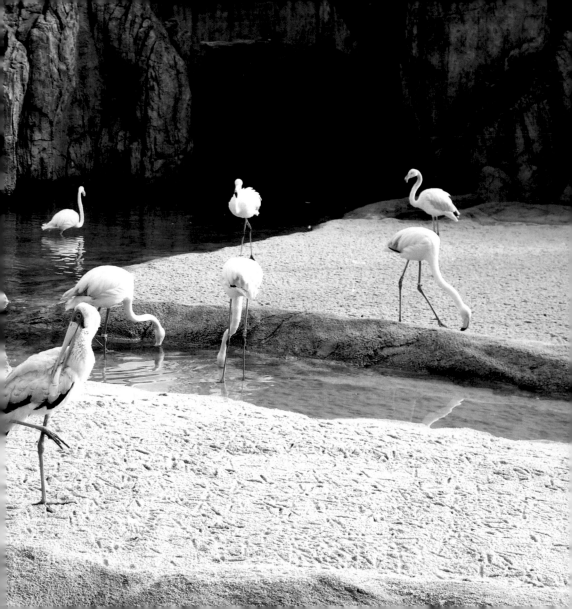

The heart of Valencia

When Valencia was first discovered by foreign travellers in the 18th century it was described it as a city of bridges and belfries, a city of orchards, gardens, palaces, churches, convents and monasteries. Frenchman Victor Hugo envisaged Valencia to be a city of a hundred bell towers as he surveyed the horizon from the Micalet, with the sea in the distance. The city's mixed profile made this a safe destination for travellers, surrounded on the outskirts by animal farmsteads and irrigated agricultural lands.

This historic centre and heart of the city, once secreted behind battlements nowadays presents itself to the visitor as a cluster of six districts in which the heart of the city still beats. This circular zone, skirted by the number 5 inner city bus route, is one of the largest surviving of any European city to still be able to testify to its urban history after almost two thousand years in existence.

The most ancient and spectacular, institutionally recognised representation of both divine and earthly power is to be found in the Barrio de La Seu, the area which leads towards Xerea, the Jewish and Arab slum districts. The vital pulse of what was once Valencia's walled city continues to revolve around the market place where the centre of gothic commerce and the modernist market are set face to face. Sant Francesc was the name given to the area which was a former monastery site and which has now been adopted by the Ayuntamiento or City Council. The old city weaved its urban expansion southwards when the nearby stretch of river dried up, opening up a route between the crops and disentailed properties. Trades craftsmen and the common people were raised in the working class districts of Carme and Velluters, where they lived in narrow cramped buildings which in many cases have failed to survive the passing of time. These five names constitute the city's basic framework, and a starting point for our tour of the city.

The city's gothic centre is equally as attractive by day as by night

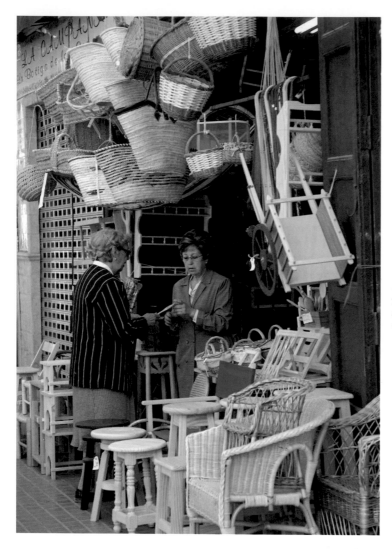

The old way of life is still kept alive in the city's historic centre

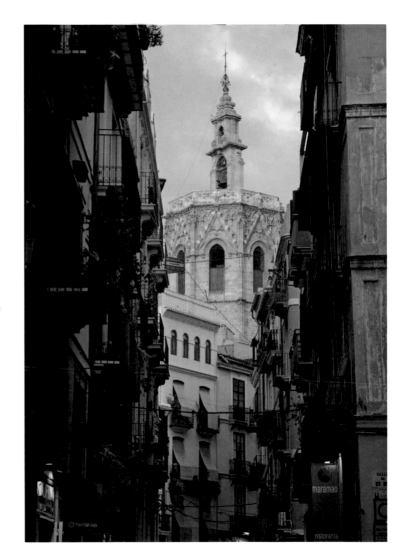

The mighty Micalet towers above narrow streets with almost touching balconies

♦ *The workmanship of fine artisans is to be seen hanging from the doors of the aristocracy's homes*

49 ◊ *What was once a pharmacy on calle Caballeros now transformed into an evening terrace bar*

The city walls

For a period of eight centuries, from the 11th to the middle of the 19th century, Valencia was always protected by its city walls. Any visitor now taking the number 5 bus will cover exactly the same route as the old city walls. The symbolic image of the city's historic centre, known as the Ciutat Vella is signified by a layout made up of concentric circles of which the central axis is the Micalet and the extremities of the radial axles are the Cruces de Término, the crosses which marked the municipal boundary, located on the main roads.

Nowadays there remains only partial testimonies of this great civil project responsible for the construction of the Fábrica de Murs e Valls financed by revenue from the wheat trade. Of the sturdy Arab wall structure constructed by the rey de taifas or Muslim king, Abd al-Aziz, there remains only the Portal de Valldigna, in the calle of the same name and a section of the wall and tower in adjacent streets.

King Pedro IV el Ceremonioso decided in 1356 to integrate what was the Arab slum district by constructing a new section of wall which was three times the size of the original Arab version. He was preparing the great Christian city for what was to be its golden era in the forthcoming century. Entrances to the city were protected by numerous towers and gateways which by night left the city completely incommunicado with the outside world.

The portal de Valldigna was once a gateway in the old Arab walls

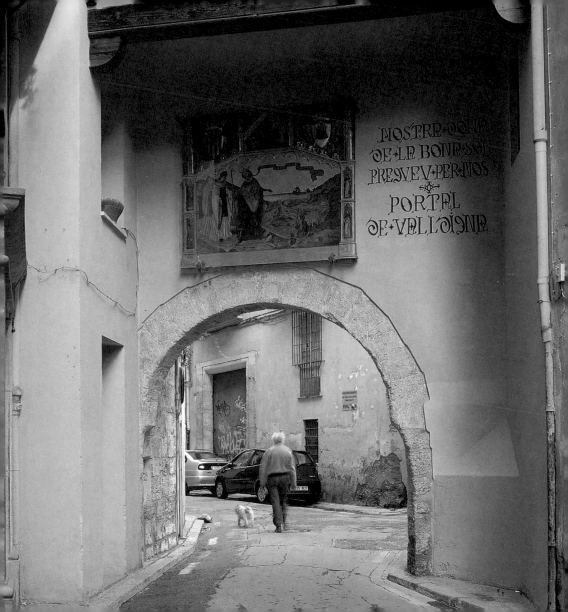

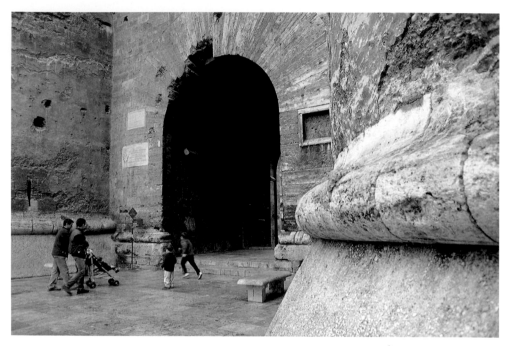

The main gateway and route by which travellers from Catalonia and Aragon arrived was the Torres de Serranos, with almost the same artistic attributes as in a triumphal arch. Pere Balaguer was responsible for the construction in 1391, built along the same lines as that of the Poblet monastery. The upper rooms served as a noblemen's prison. During the 1936 Spanish civil war it was used to protect Spanish cultural heritage artefacts removed from Madrid during the siege of Franco. Another fine example of the old wall structure is the Torres de Quart, also the work of maestro Pere Bofill and constructed in 1444, with a similar appearance to those of the Castel Nuovo gateway in Naples. The walls still display the open holes caused by French canons in 1808.

The Carmen district is accessed through the huge Torres de Quart gateway

The Torres de Quart still bears the marks left by French artillery fire in 1808

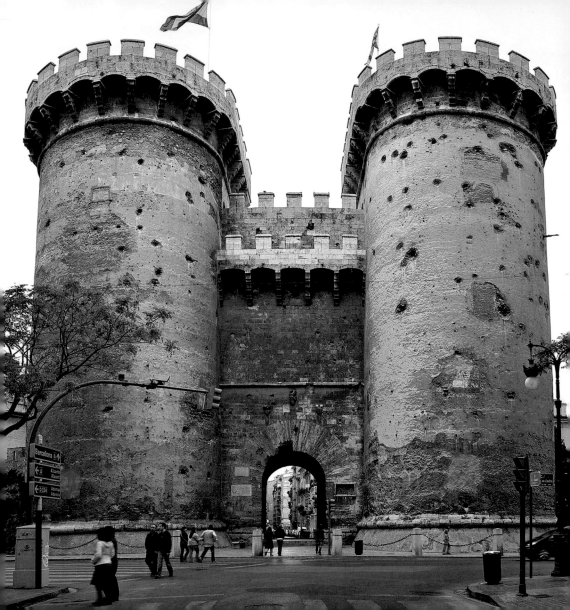

♦ *A world of mystery lies behind the history of the gothic gargoyles*

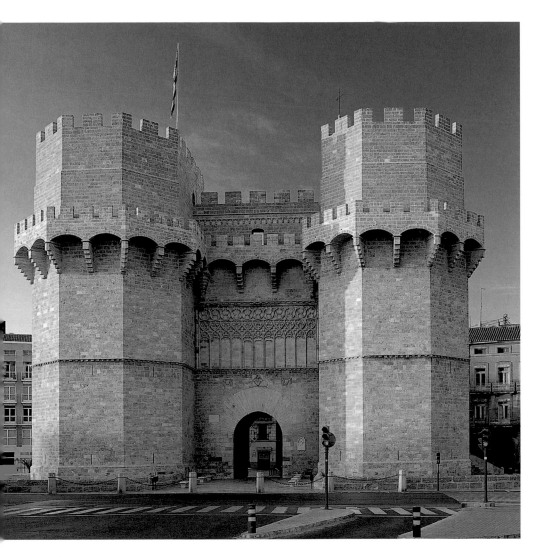

55 ♦ *The north-facing Torres de Serranos was the most elegant of the medieval city's gateways*

Palau de la Generalitat

This is another notably attractive gothic building which was also constructed over a long period of time, construction having begun in 1418 and finally completed in 1952. The oldest part constitutes the tower which looks over the Plaza de la Virgin and the main body of the building, whilst the most recent is the second tower, of 20th century construction and a replication of the first to extend the building.

Being the official governmental seat of the Valencian Community, the Palau represented in its time the continuity of the history of the ancient regional or what were known as foral laws, which came into being in the 13th century when the King of Aragon, Jaime I created the Kingdom of Valencia, this city being the designated political and administrative capital of that kingdom. Representatives from the various region's political powers on the foral Assembly in the Middle Ages are immortalised for all to see in large paintings hung beneath the beautiful wooden gallery of the Salón de Cortes. Off the mezzanine is the luxurious Salón Dorado, the site of official receptions held by the Presidente de la Generalitat, the head of regional government. The gothic patio and staircase are particularly outstanding creations by maestro Pere Compte, the most popular architect of the time.

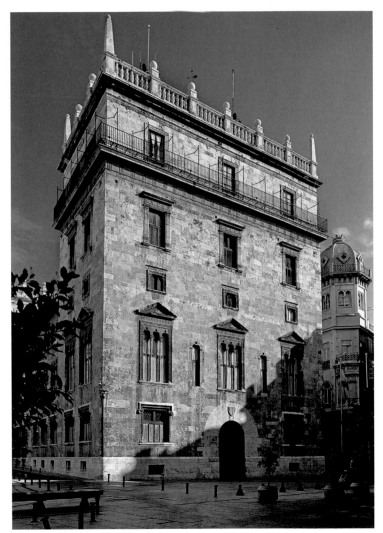

At the Palau, the most modern tower is actually the offices for the Presidente de la Generalitat, the local government head

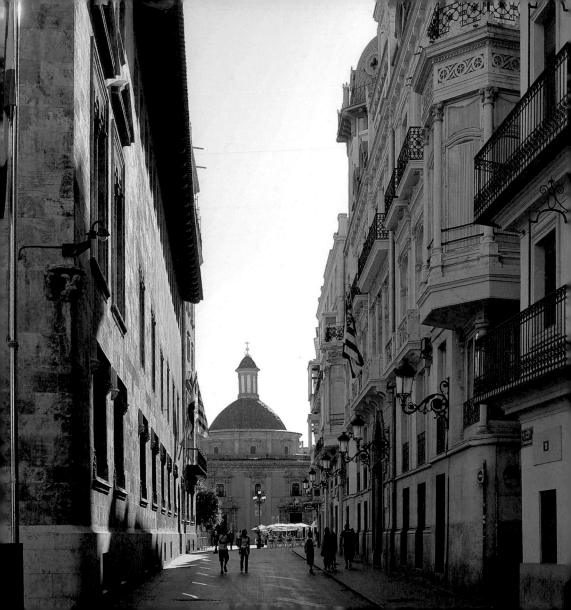

The Valencian Government and other political institutions installed in the old buildings on calle Caballeros add important social status to this historic centre

59

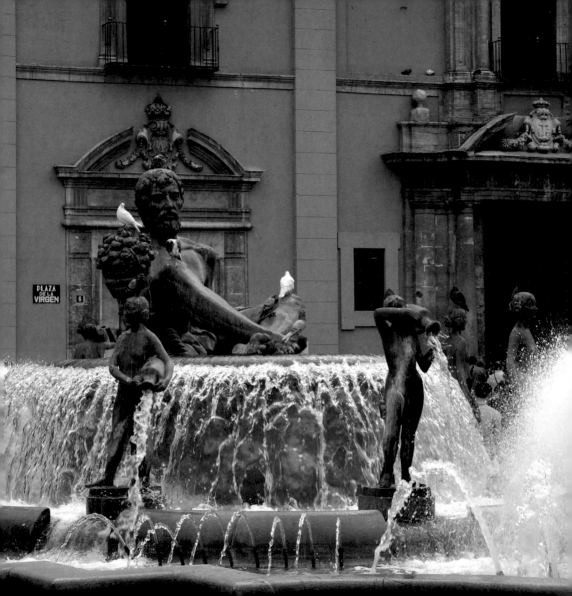

Plaza de la Virgen

One of the most distinguishing features of this pedestrian plaza is water, also the element most associated with history and tradition. The solemnity of institutional and religious power is also well represented and defined within this urban space.

Beneath the shadow of the Micalet lie two great historic buildings, the Cathedral with its gothic façade and the Basílica de la Virgen de los Desamparados, raised in honour of the city's patron saint, and which continue in their religious tradition and represent an era in which a city's importance was judged by the splendour of its principal churches.

Directly facing these places of worship, the Palau de la Generalitat represents the area's first political autonomous power, Valencia being the administrative capital of the Comunidad Valenciana. Beneath the small garden facing onto the plaza this gothic architectural gem conserves the remains of the city's former Ayuntamiento from medieval times.

Each Thursday, at midday, the Tribunal de las Aguas, created in the 10th century in the time of the Moors, passed unwritten judgment, guided by the wisdom of common laws applied to the Valencian conflicts resulting from the use of the water. The court was made up of representatives from the various sections of irrigation channels which supplied the Valencian crops. In the meantime, water was to be heard gushing from the fountain which represented the waters of the Turia and the irrigation channels it supplied.

A fountain tribute to the river Turia and the water channels which irrigated Valencia's crop growing regions

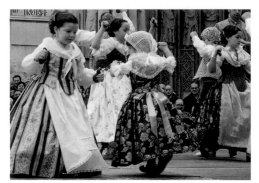

Plaza de la Virgen is a bustling plaza which perfectly demonstrates the people of Valencia's love of street life, any time of the day or night and at any time of the year

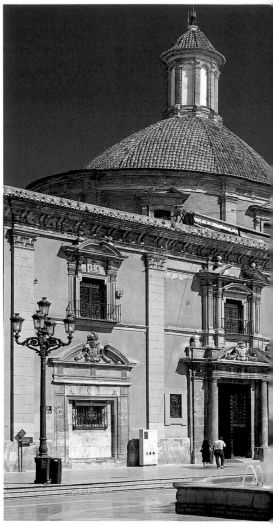

This plaza or Square is an authentic medieval agora where civil and ecclesiastical powers have been brought together

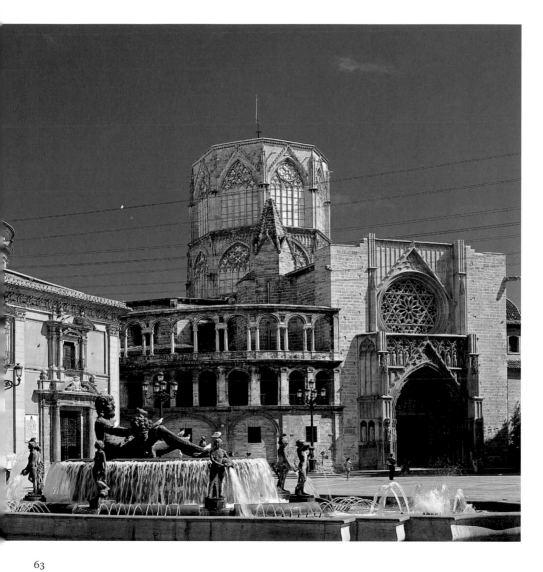

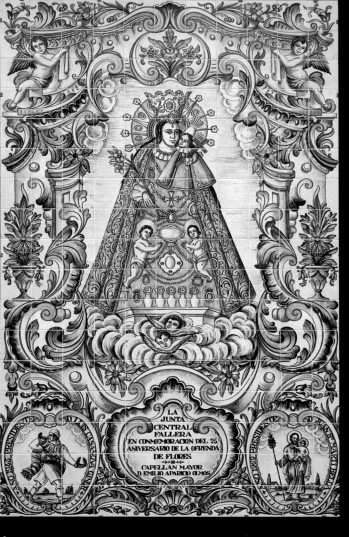

*Popular mosaic of
the Virgen de los
Desamparados, the patron
Saint of Valencia*

*Popular devotion keeps
mariological tradition alive
and well*

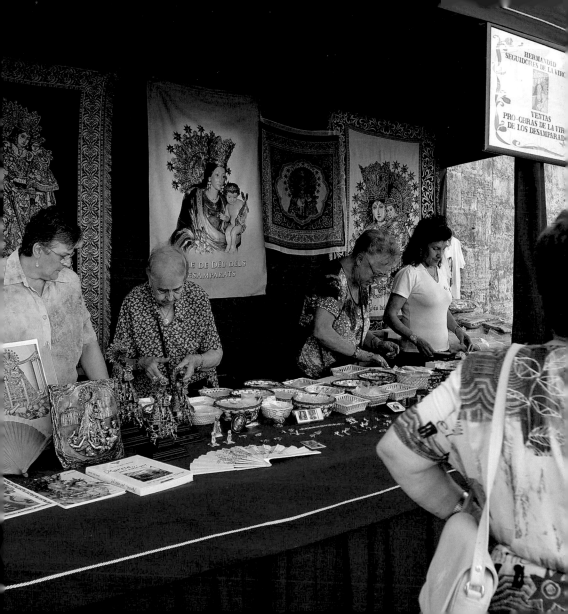

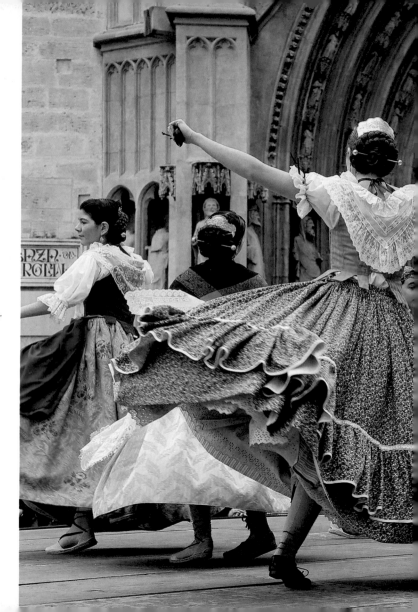

Plaza de la Virgen plays host to the most popular events on the city's traditional fiesta calendar

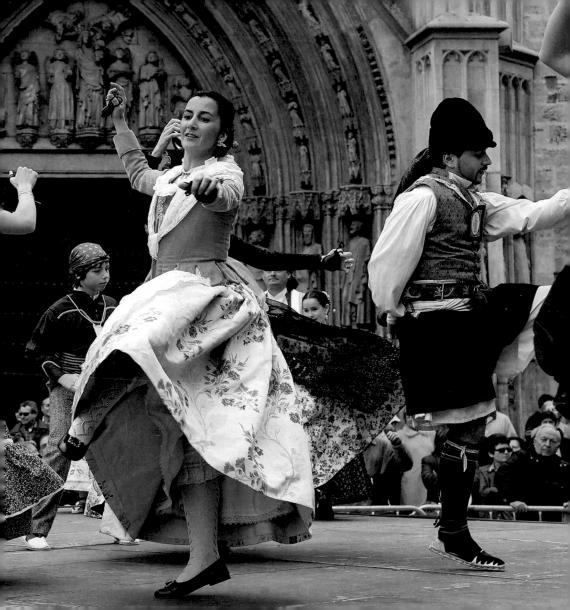

The Cathedral

Construction work began on the gothic-style Cathedral in the 13th century, a time when Brother Andrés Albalat was bishop, with its three large aisles, a transept covered by a monumental cupola and a polygonal shaped apse finished with chapels it wasn't finally finished until the early 18th century. This being the case, over the years the Cathedral has become a mixture of Romanesque, baroque and neoclassical architecture. However, in the 20th century, work was carried out to actually remove the cathedral's neoclassical covering.

The history behind this blend of styles, typical of Valencian construction methods, is exemplified in the cathedral's three main portals. The first, La Puerta del Palau, is of archaic Romanesque style, typical of the Aragon Crown period and verified by corresponding cathedrals in Lérida and Tarragona. The portal includes representations of seven couples, possibly married couples from amongst the settlers being soldiers from the army of king Jaime I and young maidens from Lérida.

The gothic style Puerta de los Apósteles faces the old Ayuntamiento and plays host to the celebration of the Tribunal de las Aguas. The cathedral is filled with light from its gigantic star shaped stained glass rose window. The third baroque style portal located at the foot of the main central aisle was initially built in at the end of a narrow street which forced the architect to use curved forms to fit the most possible in the least available space. Now the entire cathedral façade including the Puerta de los Hierros can be seen from a spacious plaza.

Side door on the Palau, the oldest and most austere of the entire cathedral

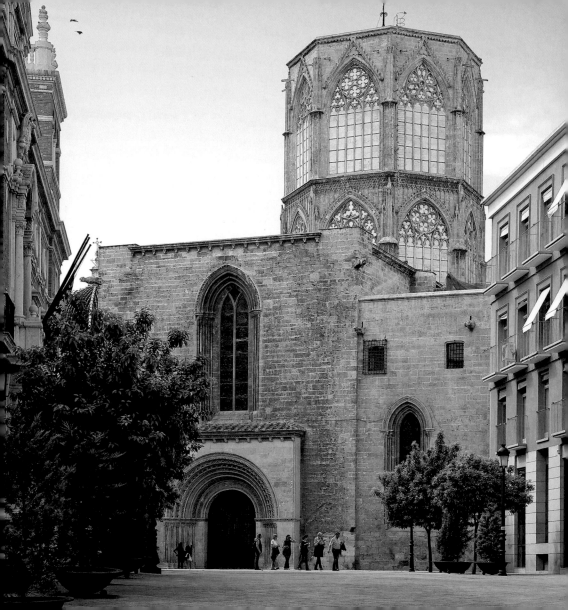

BERGA·SAMVEL

The original Romanesque
style façade portrays the
Christians who resettled
in the previously Muslim
conquered Valencian
territory

The rose window transforms
the light into a multitude of
coloured rays

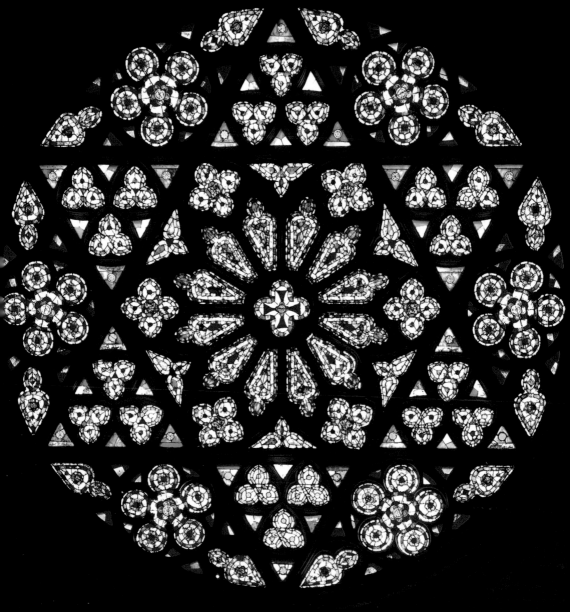

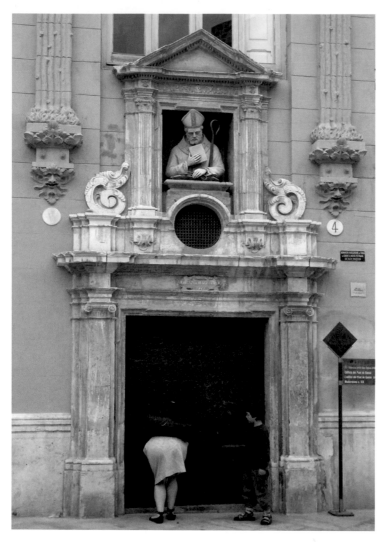

Plaza de la Almoina

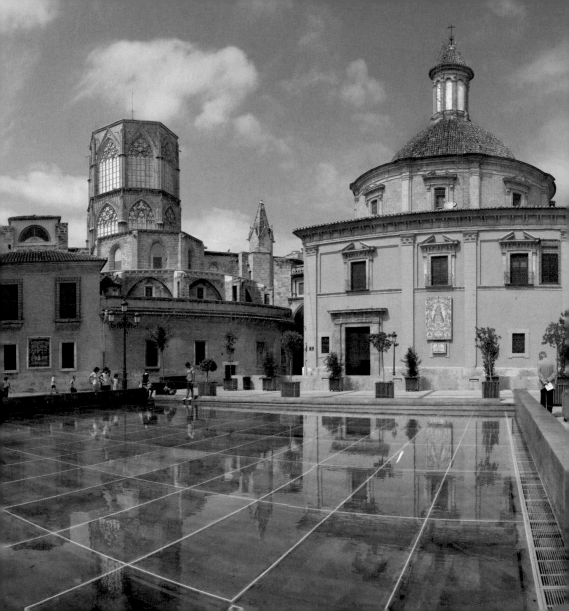

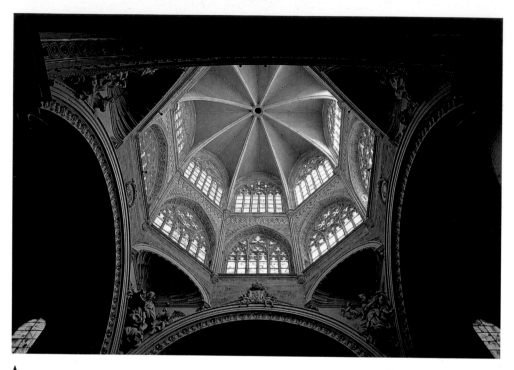

The Cathedral's spectacular cupola literally floods the main altar with natural light

Every Thursday at twelve noon the Tribunal de las Aguas is held at the Gothic Puerta de los Apóstoles gateway

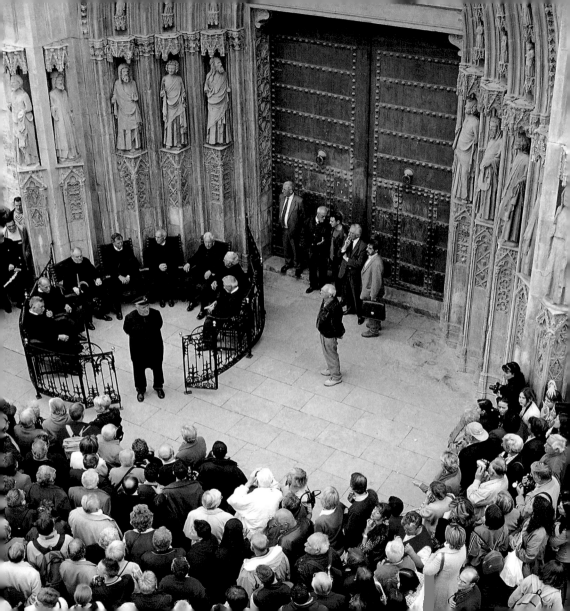

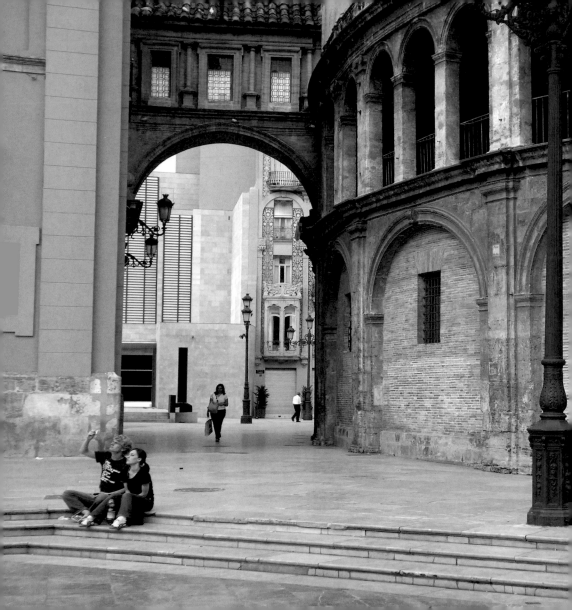

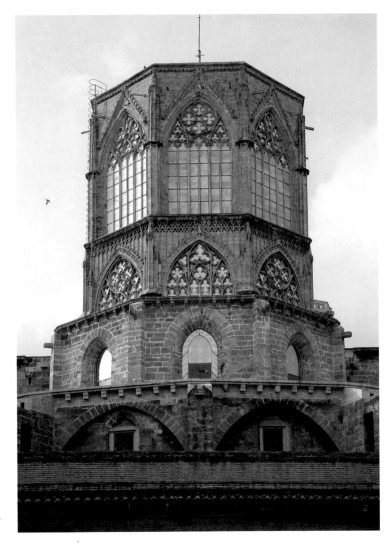

The passage linking
the Cathedral to the
Archbishop's palace

The cupola is one of the
Cathedral's most spectacular features

The shortage of space meant the design of the facade had to be concave and convex

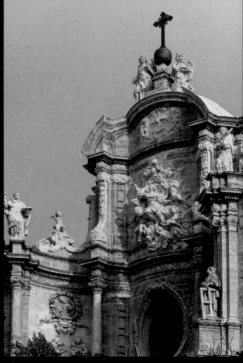

The baroque façade, representing the Asunción of the Virgin, is the work of sculpture Vergara and architect Conrado Rodulfo

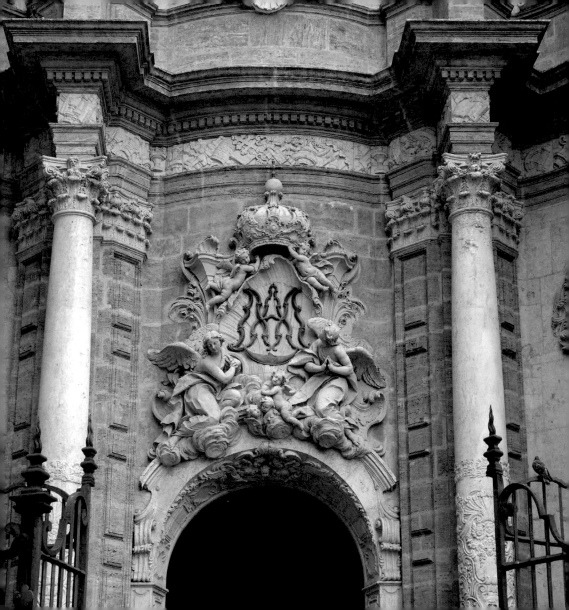

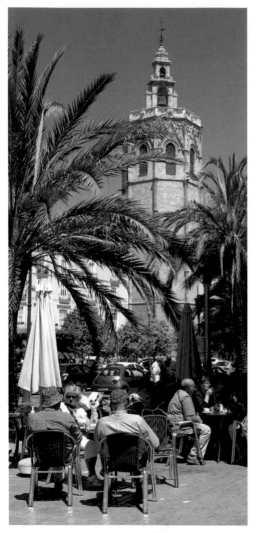

The Micalet was initially born a bell tower completely separate from the original cathedral. The same can be said for the Aula Capitular, which according to belief preserves the Holy Chalice and the Holy Grail from the last supper. This gothic style bell tower is almost 60 metres high with a spiral staircase with 207 steps and a dozen large bells, it has for many years been recognised as the city's emblem.

The chime of the dozen bells reverberates clearly through the large ogive shaped windows, the heaviest having been cast out of eleven thousand kilos of metal. To keep this old tradition alive, an association of bell-ringers often organises special bell-ringing demonstrations on Sundays The effort to climb the spiral staircase is well rewarded by beautiful views of the old city.

The Micalet seen from the
Plaza de la Reina

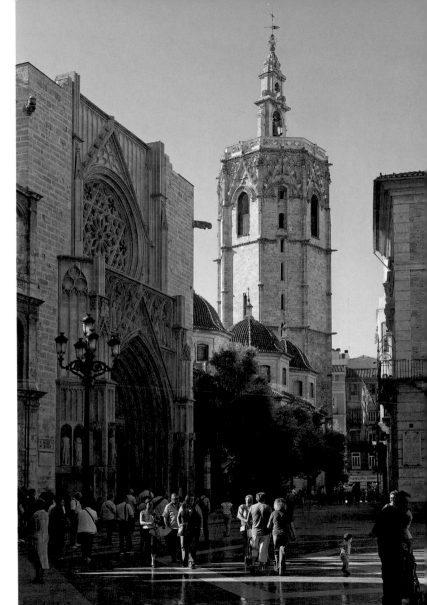

The twelve apostles on the gothic façade observe the permanent comings and goings of passers-bye and tourists

Panoramic view over Plaza de la Virgen and the Cathedral terraces and cupola from the Micalet tower, at a height of 60 metres

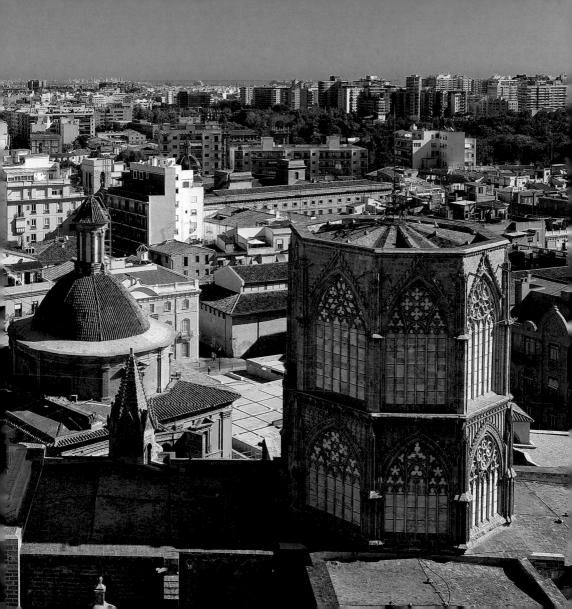

Plaza de la Reina

The essential now familiar phrase came to us from Juan Gil-Albert, who rather succinctly summed up the plaza in these few words: "the Micalet is in Valencia, the torre de Santa Catalina is Valencia". This grammatical differentiation between temporary and permanent states marks the difference between the established solidity of gothic architecture as opposed to the more delicate baroque architecture.

The iglesia de Santa Catalina, at the start of the Mercat district, is of gothic design as regards the main body of the church, although the tower, a later 17th century construction by Juan Bautista Viñes, comes under the artistic dictates of baroque architecture in search of a slight variation on the hexagonal shaped Micalet, reduced in height with more slender walls. Rather like a younger sister, who begins by imitating her big sister and by the end of her adolescence emerges with a totally different personality.

The Plaza de la Reina is a semi-pedestrianized area and the outcome of demolishing the numerous streets and old houses which formerly boxed in the south face of the Cathedral. The plaza, now filled with typical horchaterías, chocolaterías, bars and terraces, is the ideal place to enjoy a refreshing drink and make the most of the Mediterranean sun and light.

The baroque tower on the Santa Catalina is the little sister to the gothic Micalet bell-tower

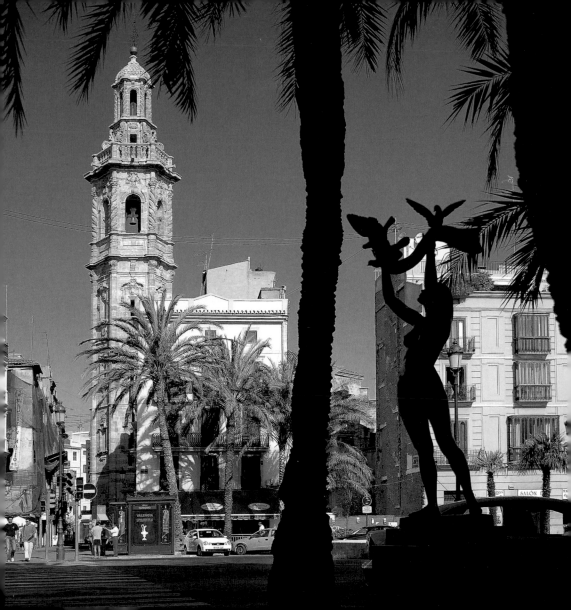

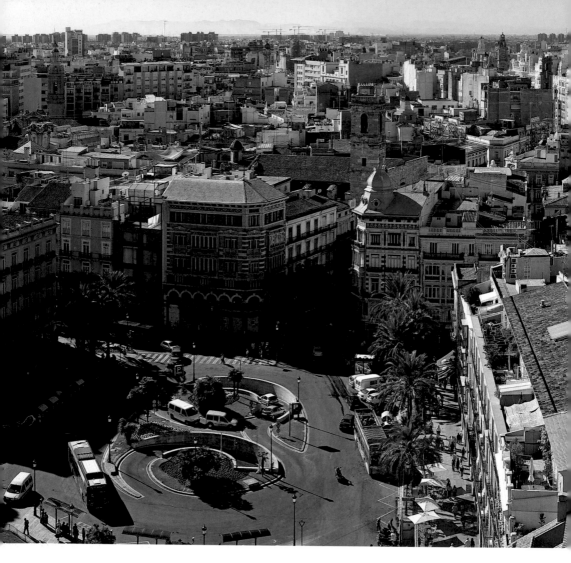

86 *Panoramic view over plaza de la Reina and the Santa Catalina church from the top of the Micalet*

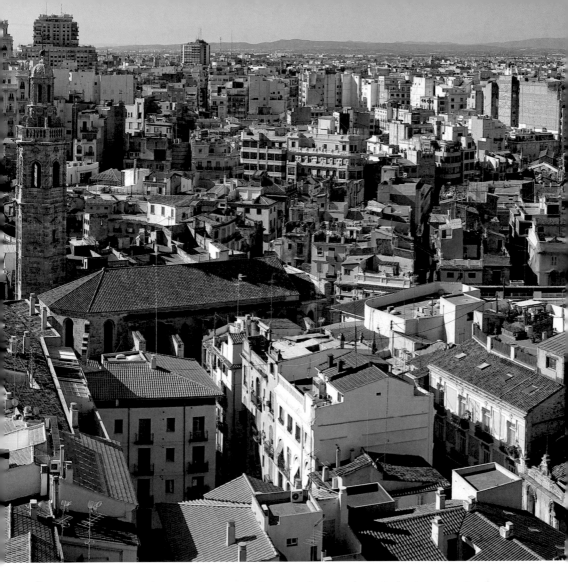

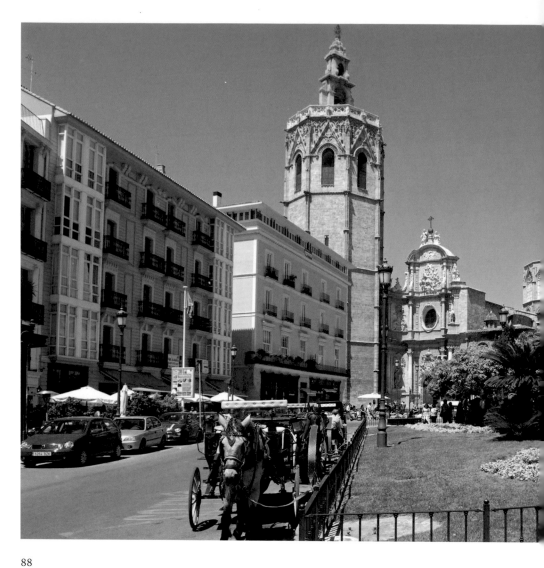

The recent restoration of
the Santa Catalina has
returned the church to its
former gothic splendour

Plaza de la Reina

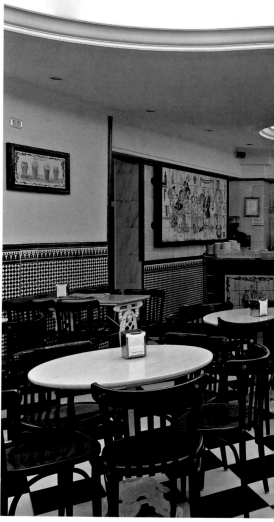

The Santa Catalina chocolatería is an obligatory stop on a tour of the historic centre, the place to partake of a horchata (drink made from tiger nuts) with fartons (long thin type of doughnut) or a drinking chocolate with buñuelos (a type of doughnut)

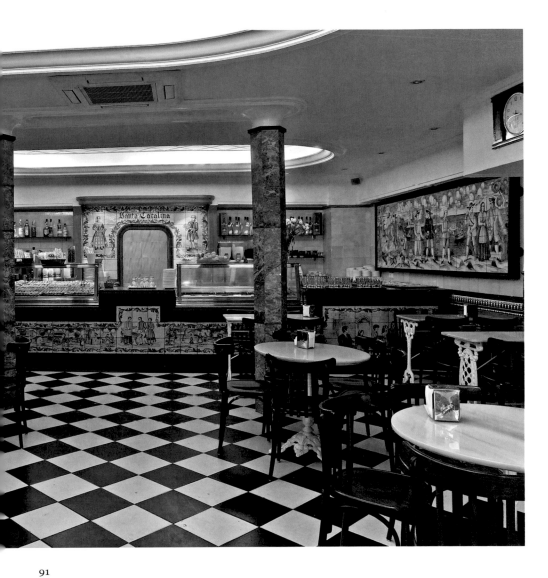

La Llotja de la Seda

Declared a World Heritage Site by UNESCO in 1996, this building is one of the most beautiful examples of Mediterranean Gothic civil architecture. Situated in the heart of the medieval quarter of the merchants, it was built as if it were a cathedral, but with the essential difference that its use was to be secular and worldly. This is because inside its walls mercantile contracting took place as well as the administering of justice in maritime lawsuits. The incipient bourgeoisie, civil society, financed its construction.

Built by Pere Compte as from 1483, it has three sections with different uses: the columned hall as a contracting space, the central towers used as a prison and the building of the Consolat del Mar reserved for the court that administered maritime law. Also here was the office of the Taula de Canvis i Depòsits, the first bank of the time the role of which was to finance the trade.

The height of more than 17 metres of the main hall enables the 24 spiral columns to open out on reaching the vault as if they were palm trees. The high part of the walls is ornamented with a long Latin inscription that highlights the goodness of commercial activity and recognises that accumulating wealth is not incompatible with gaining eternal life. The architect undertook his brilliant work guided by notable symbolisms. Their secret messages appear reflected in the gargoyles and other ornamental elements.

This Gothic area puts on its Sunday best when the King Jaume I Prizes are awarded, for scientific research and development, promoted by the Generalitat Valenciana and the Valencian biochemist Santiago Grisolia, disciple of the Nobel Prize winner Severo Ochoa. Presided over by the Royal House, it brings together the most prestigious scientists in the world on its juries. The prize-winners go on to form part of the Consultative Council for Research and Development of the Valencian government. The King Jaume I Prizes were created in 1989.

La Llotja (Stock Exchange) is an architectural tribute to commercial activity and finance

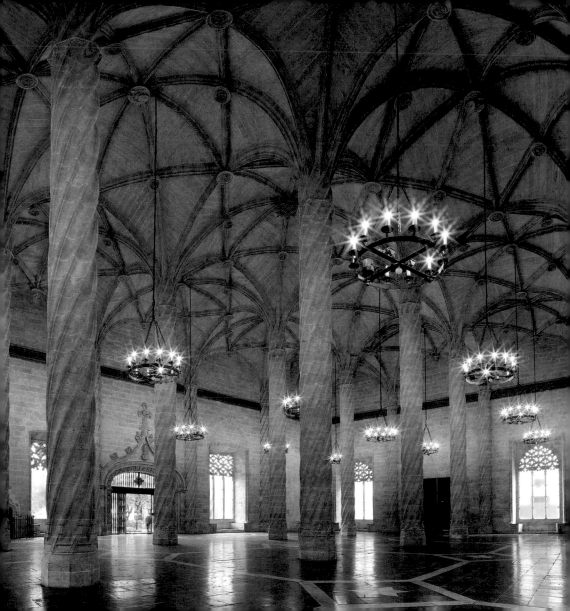

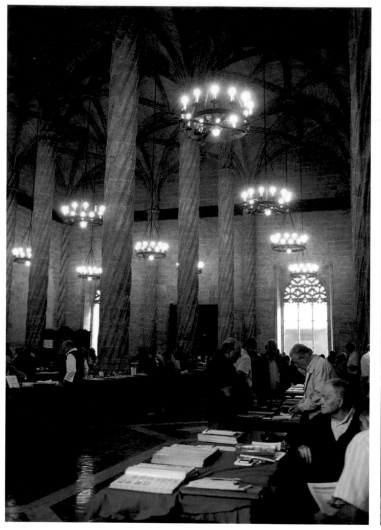

◆ *This building houses the headquarters of what was the first commercial bank*

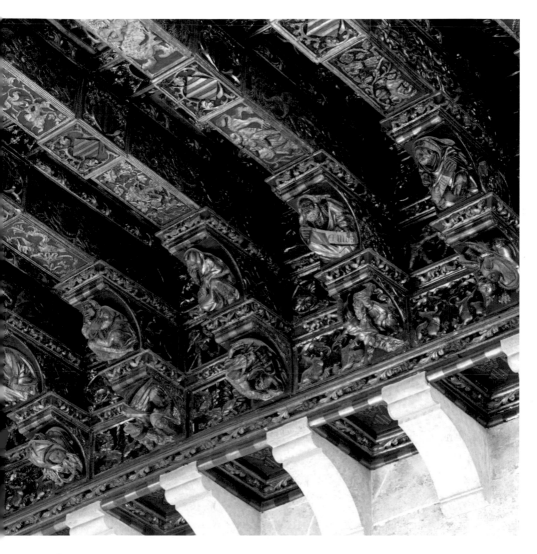

The spectacular coffered ceiling of the Consolat del Mar comes from the old Town Hall

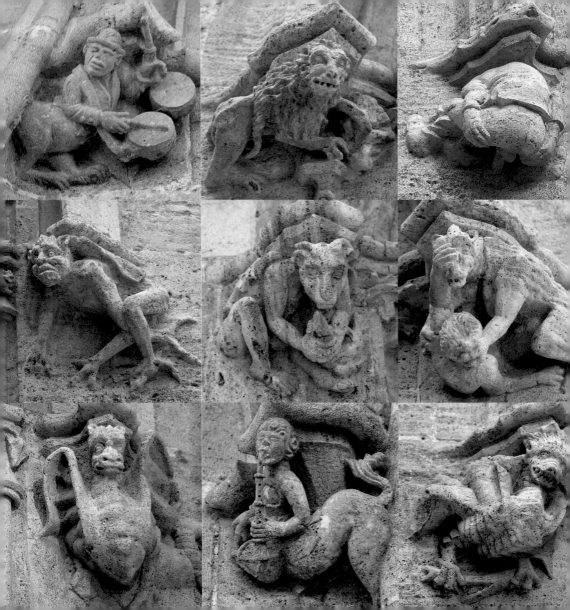

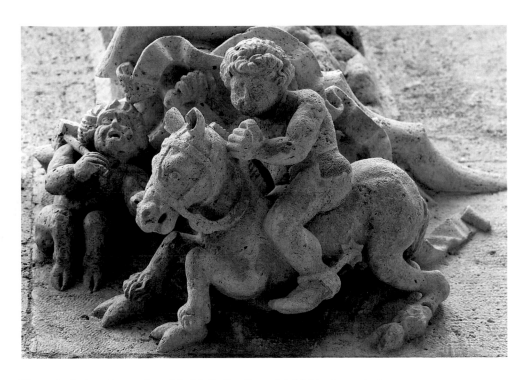

Through the interior garden of La Llotja the Consolat del Mar is reached via a beautiful and solid stairway, the area characterised by a marked Renaissance style on its façade. It conserves the delightful carved and polychrome coffered ceiling that the old town hall showed off, the one knocked down in the current Plaza de la Virgen. The luxury of the hall is emphasised on taking in the painting that reproduces the jurors of the city when they worship the Virgin.

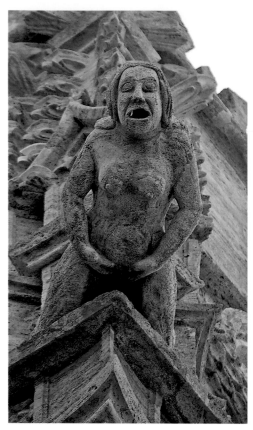
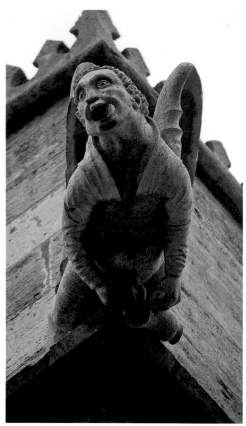

The gothic building's supposedly secular character
is reflected in the fantastic obscenity and pretension
of the gargoyles and external façades, almost
imperceptible from a distance in the visitor's eyes

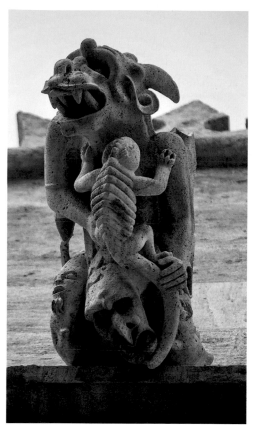

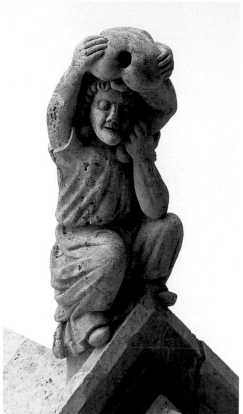

El Mercat Central

In the plaza del Mercado, it appears there has always been an incredible bustle of commercial activity. Firstly, wooden, canvas covered stalls displaying their locally grown produce in the street. Later, at the onset of the 20th century, a huge modernist style market was constructed in response to the city's growth and as a sign of its renovation, the Mercat Central was a genuine tribute to the social euphoria of the time, a resplendent temple for the palate, which offered street sellers more convenience and security and buyers more variety and quality.

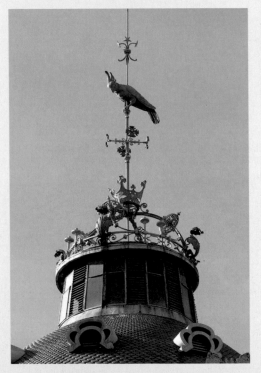

Architects Francisco Guardia and Alejandro Soler created this amazing piece of commercial architecture between 1910 and 1928, highlighted as it is by the attractive ceramics, coloured glass windows and iron and steel structures.

At the present time more than 1,000 market traders fill their stalls with fruit, vegetables, meats, fish and seafood products.

The weather vane on the roof of the cupola is known as "the market parrot"

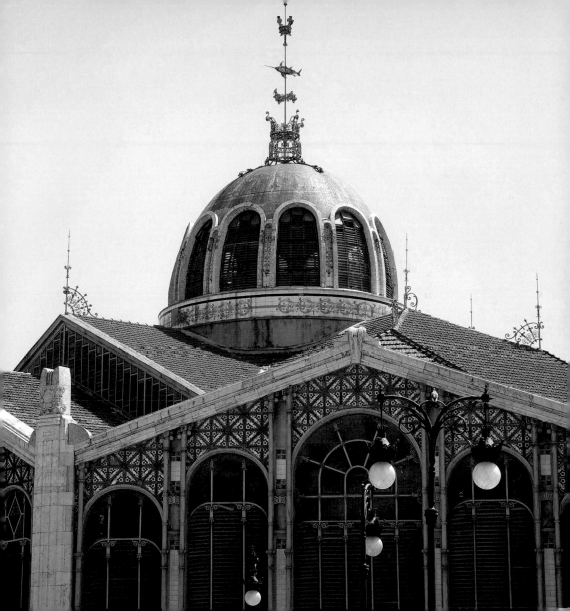

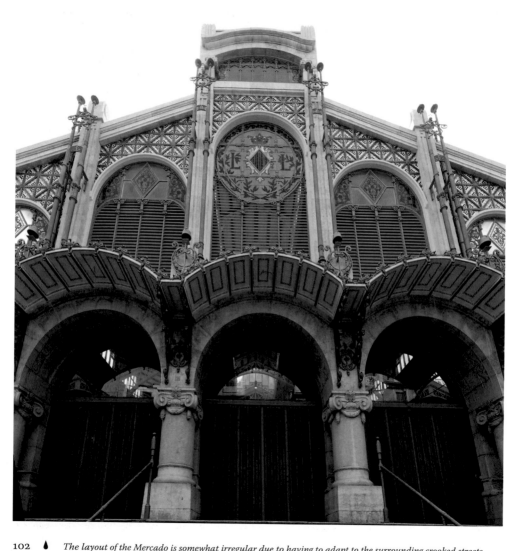

◗ *The layout of the Mercado is somewhat irregular due to having to adapt to the surrounding crooked streets*

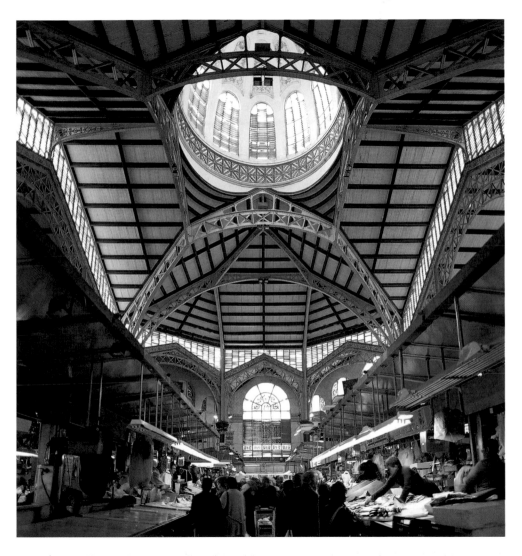

♦ *The huge central nave is finished off by a spectacular vaulted ceiling*

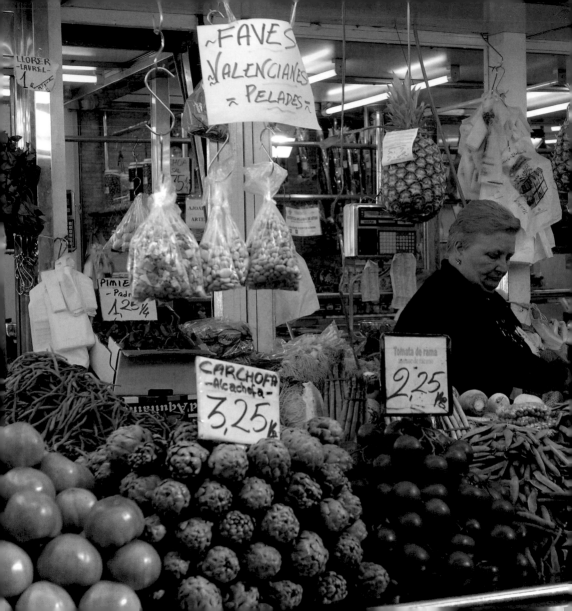

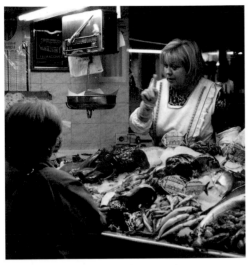

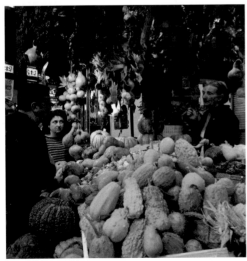

♦ *An immense showcase of colours, tastes and scents*

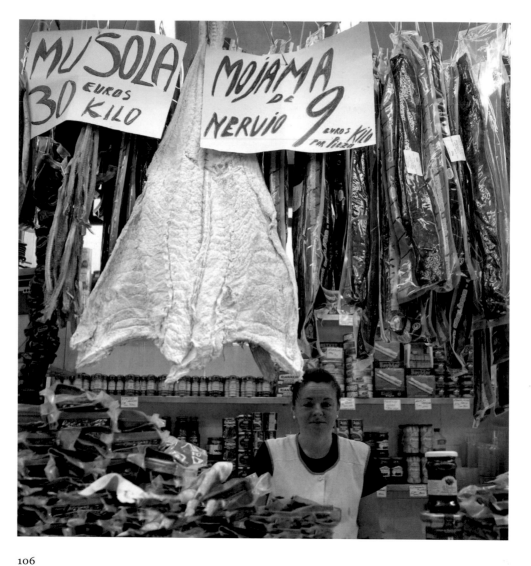

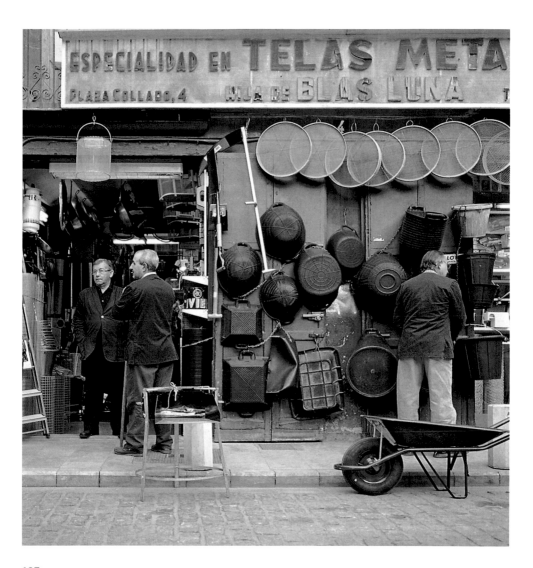

107

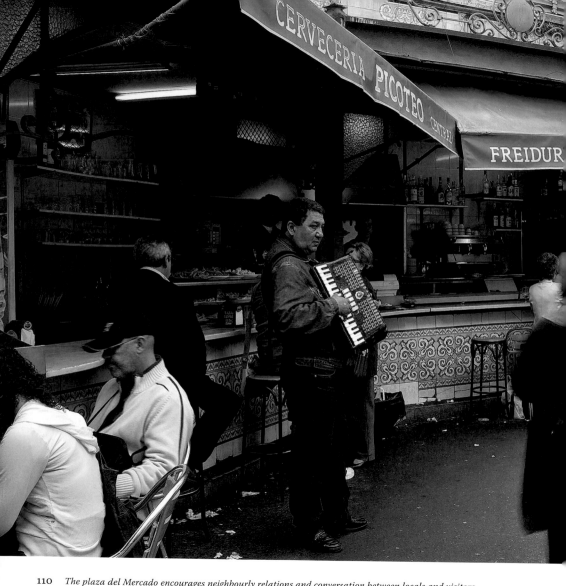

The plaza del Mercado encourages neighbourly relations and conversation between locals and visitors

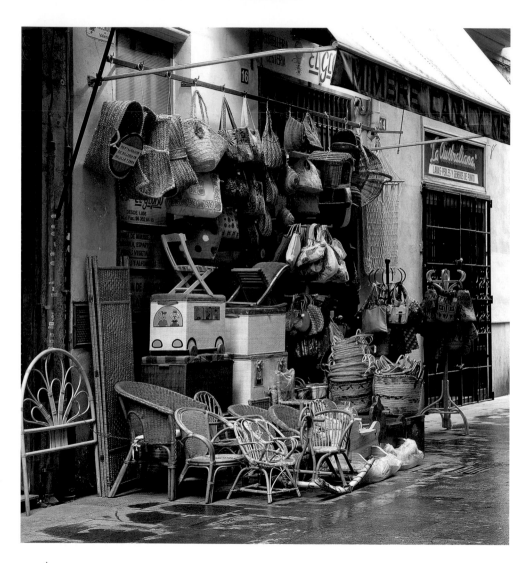

♦ *Around the market, diverse traditional trades sell their wares*

In a way, Valencia has and to a certain extent continues to be, a city of small businesses and traditional crafts. Streets are filled with wickerwork, wooden furniture, esparto, herbs and spices, old books, fabrics, antiques and jewellery. This same medina like atmosphere also breathes amongst the old shop premises in and around the Plaza Redonda with similar products. Having neither bulls nor terraces, this circular area was originally the site of the local fish market, the reason for which there is a noisy gushing fountain in the centre.

Plaza Redonda was originally the site where the fishmonger's gathered in the historic centre

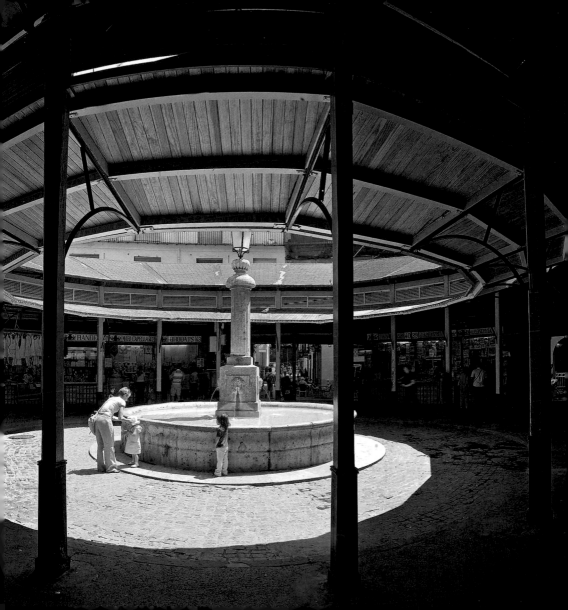

116 ◆ *The shops on plaza Redonda specialize in work and school uniforms*

TShops which promote the essence of Spanish tradition

◗ *Shops by day, bars by night*

Plaza del Negrito is a
peaceful place to partake of
an evening drink or "copa".

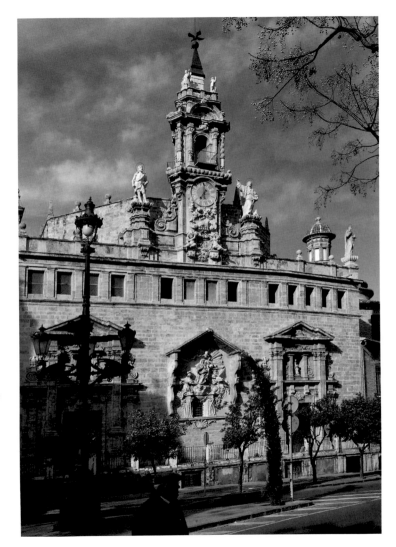

The gothic and baroque style Santos Juanes church on the plaza del Mercado, is built over what was formerly a mosque

Palacio del Marqués de Dos Aguas

This rather unusual building, which receives innumerable visitors wishing to see, above all, its magnificent baroque façade, which alludes to the noble title of its patron Rabassa de Perellós. Sculptured in alabaster from the Picassent quarries, the scene depicts a poetic allegory on water and the river with the enigmatic presence of gigantic semi naked figures. The upper section refers to the Virgen del Rosario, whilst on the section below two rivers intertwine between fauna and some form of vegetation wrapped around two gigantic bald figures one completely naked and the other semi-naked. The figures are clearly influenced by and display admiration for the human figure as depicted by Michael Angelo.

The building was originally a gothic palace with a crenellated tower. In 1740 Ginés Rabassa entrusted its reform to the architects and artists who were popular in the city at that time: Hipólito Rovira, Ignacio Vergara and Luis Domingo. To the palaces original structure these artists added the alabaster façade, the cupola above the main staircase and the frescoes on the façade. A century later this same family refurbished the building once again to further accentuate its opulence.

The sculptured alabaster façade by Ignacio Vergara is one of the most photographed sites in the city

Two giants amongst the waters placidly display their power and strength on the palace façade

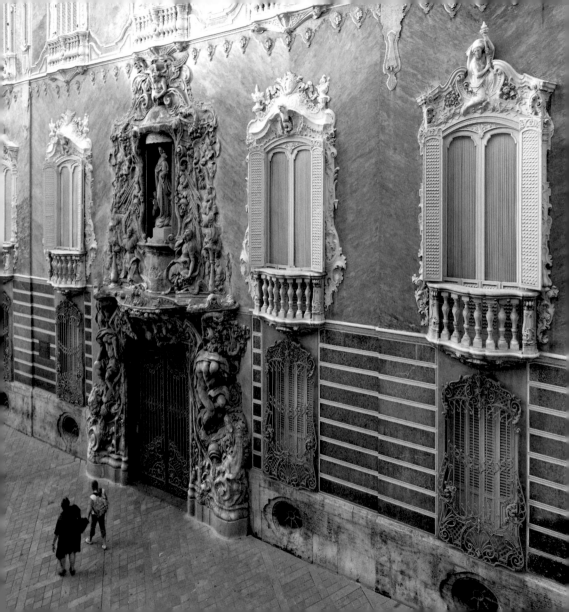

Preserved in the main section of the Museo Nacional de Cerámica Manuel González Martí is the golden lusterware and items produced from the royal factory of Alcora as well as the recent addition of 600 pieces of porcelain. Together with medieval ceramics by Paterna and Manises are 18th century carriages, amongst which is that of the carroza de las Ninfas. Other interesting exhibits in the museum include furniture by Dresde, inset with porcelain by Meissen and Berlín, Iberian, Greek and Roman ceramics, as well as a life size reproduction of a traditional Valencian kitchen.

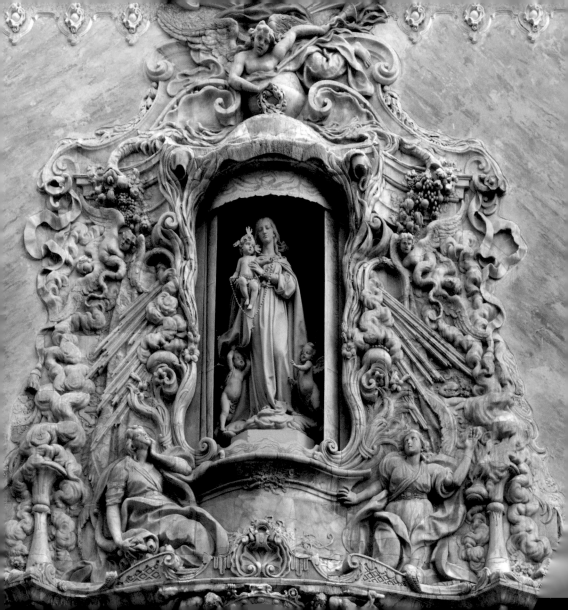

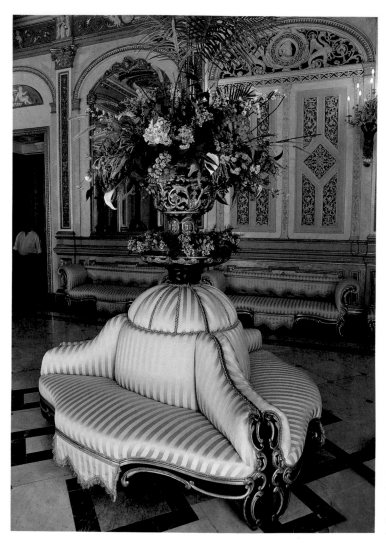

Worthy of admiration as regards the palace building interiors are the magnificent halls, typical of Valencian aristocracy in its heyday.

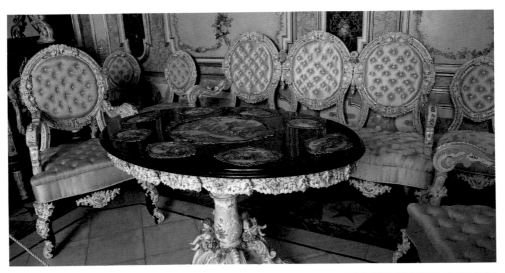

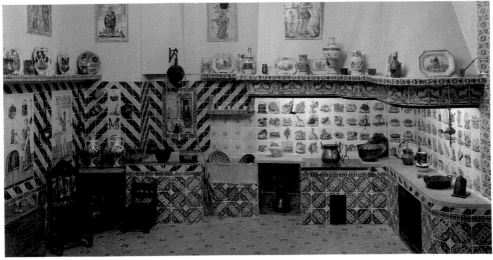

133

Plaza del Ayuntamiento

From Calle San Vicente, we come to the large, albeit triangular, plaza del Ayuntamiento with numerous buildings of different architectural origin providing a somewhat heterogeneous and eclectic image of municipal life in the administrative and financial heart of Valencia. The historic heart of this city suddenly seems to expand with the rapid beat of traffic and the constant hustle and bustle of people, reminding us that we are now in the city's main square.

Since the first city improvements were carried out in 1905, up until the present time there has always been a policy to preserve the bright, colourful flower displays and wide open spaces to accommodate the mascletás (pyrotechnic castles and fireworks displays) for the fiesta de Fallas and other celebrations when thousands of people gather in this plaza to jump, shout and applaud along with the fireworks.

The current Ayuntamiento or city council building is actually an amalgamation between the former school house building Casa de la Enseñanza located at the rear, and the new municipal centre constructed between 1905 and 1950 by architects Francisco Mora and Carlos Carbonell. Renaissance and baroque forms are combined with purism, to create this evidently monumental building. The spacious balcony on its main façade accommodates the powers that be and their special guests at fiesta time and on special occasions, whilst the clock marks the hours with the regional hymn.

The Ayuntamiento's main façade with the traditional clock-tower and fountain in the centre of the square which also serves to guide the traffic

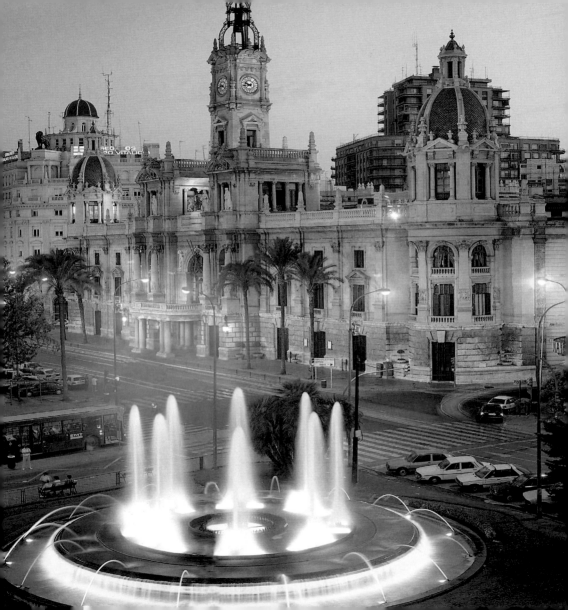

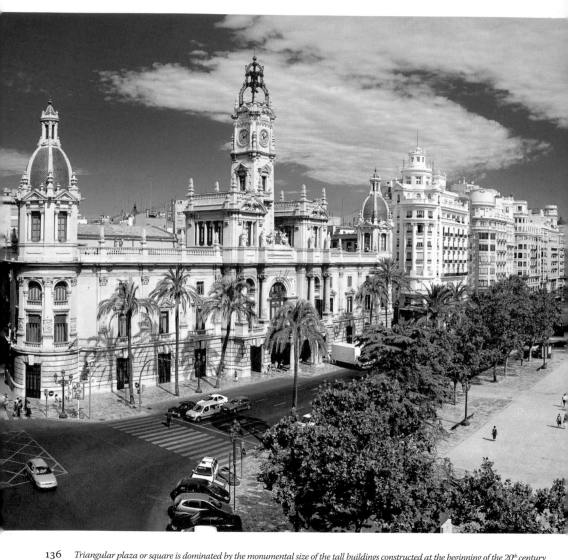

Triangular plaza or square is dominated by the monumental size of the tall buildings constructed at the beginning of the 20ᵗʰ century

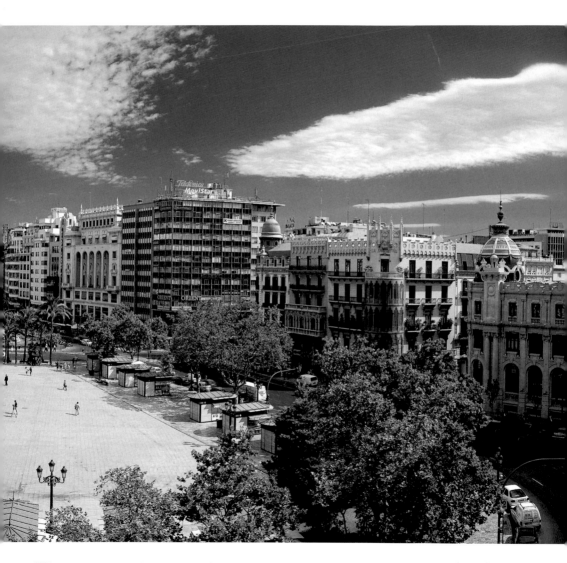

At any time of the year, any day of the week, fresh brightly coloured flowers can always be bought in the plaza del Ayuntamiento. Way back in the 20's arquitect Javier Goerlich envisaged the centre of the square to be a large area animated by flower sellers stalls and people out for a stroll.

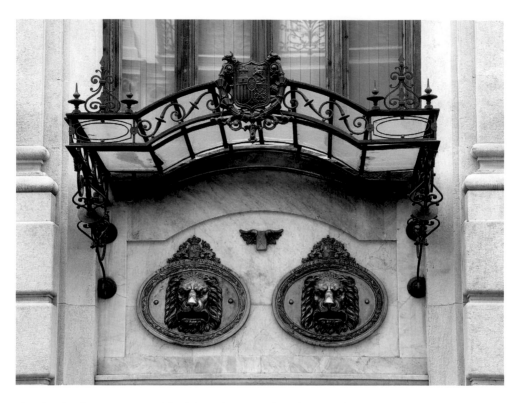

The plaza's other monumental building, this time of academicist design, is the Palacio de Correos y Telégrafos, or post office building, initiated in 1915 by architect Miguel Ángel Navarro. Each Spanish region's coat of arms is portrayed on the interior rotunda of the building's impressive wrought iron and glass cupola. The decoration on the outer façade portrays land and sea communications between the five continents.

Palacio de Correos
y Telégrafos

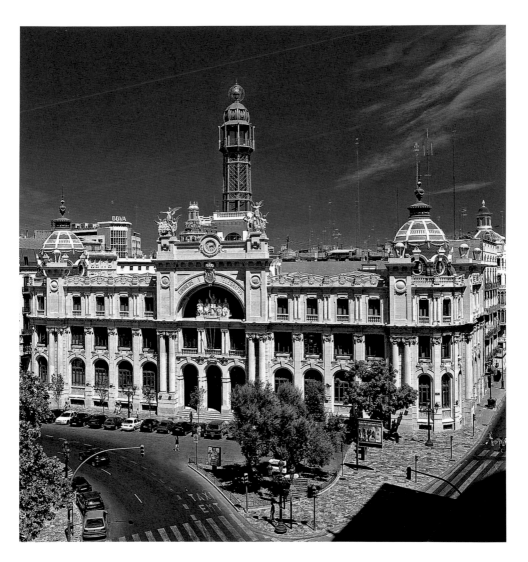

Modernist Valencia

Since the bourgeoisie and ruling classes had a penchant for the modernist movement and its architectural potential, Valencia is one of the cities with the most modernist architecture in Spain. Exuberant, ornate, colourful and geometric were just some of the modernist features which impressed Valencia's artists and architects. Modernist architecture became established in the city by appearing in large public works, city planning projects and housing. Later it also appeared in painting and sculpture.

Examples of modernist architecture include the Mercat Central and the impressive buildings in the plaza del Ayuntamiento, also the Estación del Norte and numerous accommodation blocks in the prestigious Ensanche district as well as the Mercado de Colón, a remarkable urban development. It's actually possible to make a little tour to discover modernist Valencia. Starting from the corner where calle Ruzafa meets Gran Vía Marques del Turia, there is one of the listed buildings. Next the amazing Casa Ortega, located at number 9 on Gran Vía. Casa Ferrer at 29 calle Cirilo Amorós, and Casa de los Dragones at number 3 calle Jorge Juan, all fine examples of architectural beauty.

View of Casa Ortega (1907)

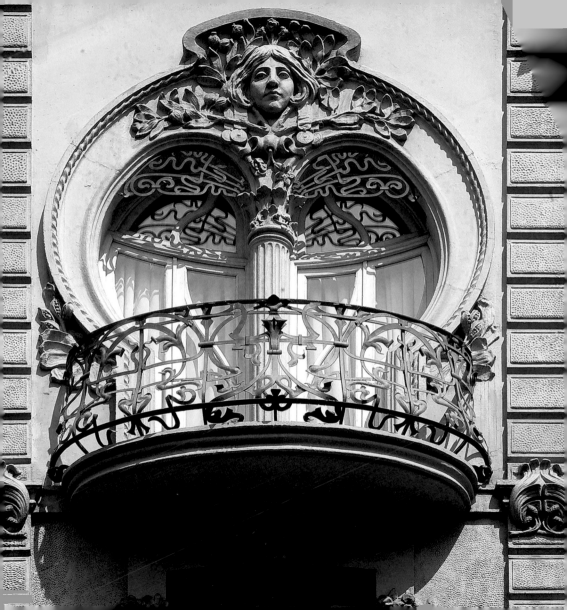

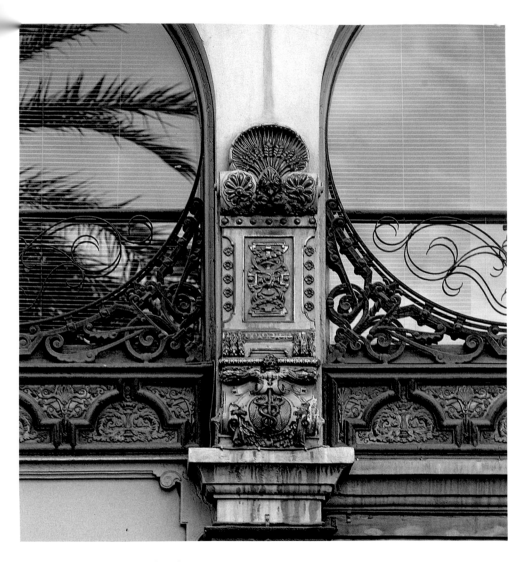

144 *Examples of Valencia's rich modernist ornamentation*

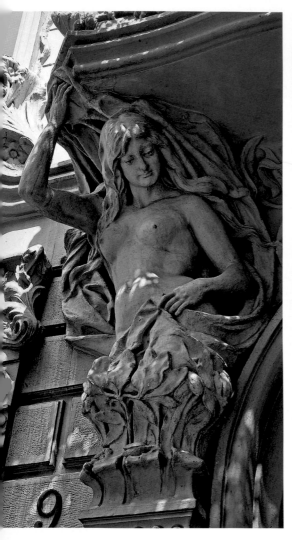

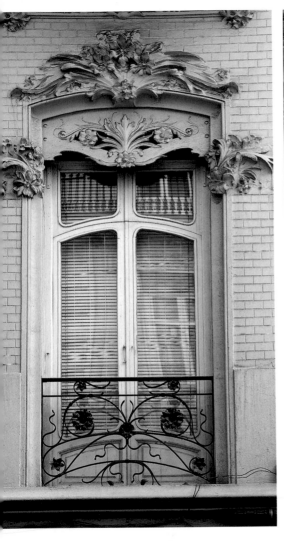
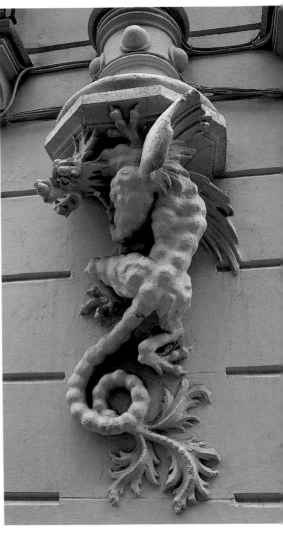

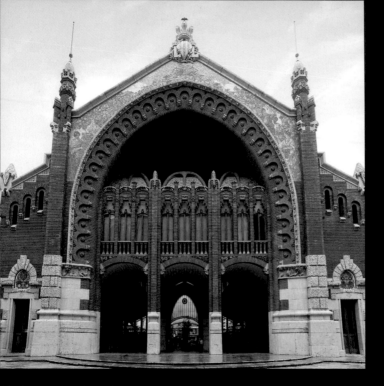

The bourgeoisie from the Ensanche district wanted to have a more opulent indoor market than the one built opposite La Llotja for the residents in the historic centre. In 1921 the Ayuntamiento (city council) decided to commission modernist arquitect Francisco Ribes to construct the Mercado de Colón, an exquisite example of its time. In the recently refurbished building one of the outstanding features is the tribute which has been made to the traditional Valencian huerta or market garden, created with mosaics and stone ornamentation. Nowadays the former indoor market has been transformed into a pleasant shopping and leisure centre in keeping with this prestigious district.

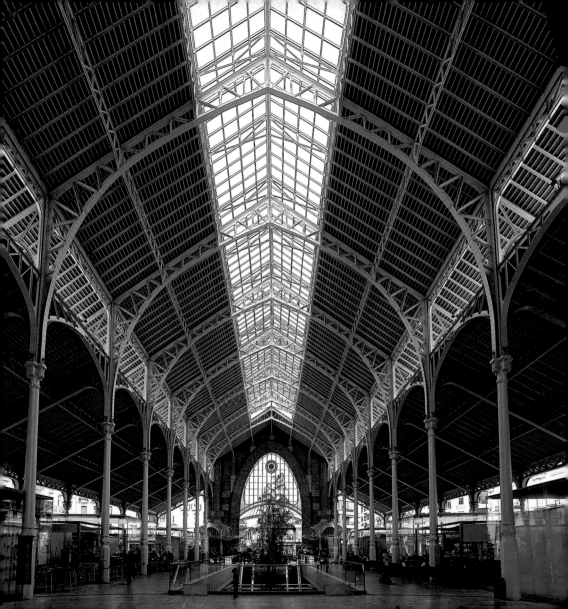

Estació del Nord

This building is located on the borders of what for centuries marked the limits of the city's old walls. This is indicative of the period in which Valencia wanted to do things in a big way and decided to remove the trains from the plaza del Ayuntamiento and provide the city's many bullfighting aficionados with the monumental setting they deserved.

The problems as regards structural cohesion in the south of the city, caused by the railway, are to be resolved shortly when the train station is relocated underground and a large park will be created above this sea of lines upon which 500 trains circulate each day.

Estació del Nord sees more than 90,000 passengers come and go each day, all of which immediately find themselves in the city's main commercial and services zone. An authentic river of people passes through this splendid building which was constructed by Demetrio Ribes between 1906 and 1917, of a predominantly modernist look with just a touch of Austrian styling. All the main principals behind the flourishing local society are represented within its ornamentation.

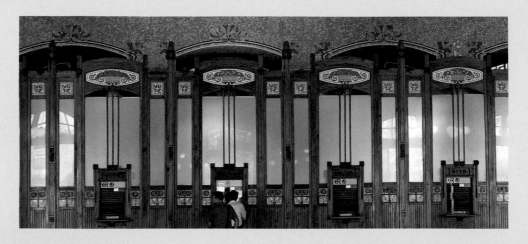

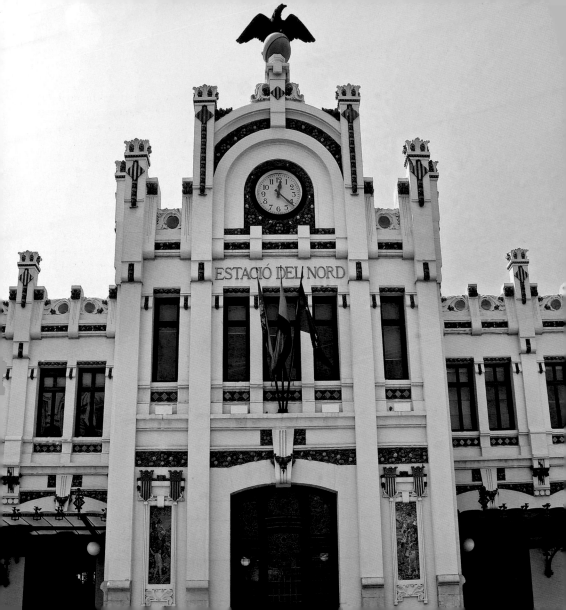

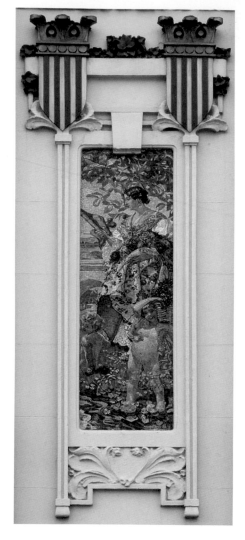

♦ *Mosaics represent the values most typical of the people of Valencia*

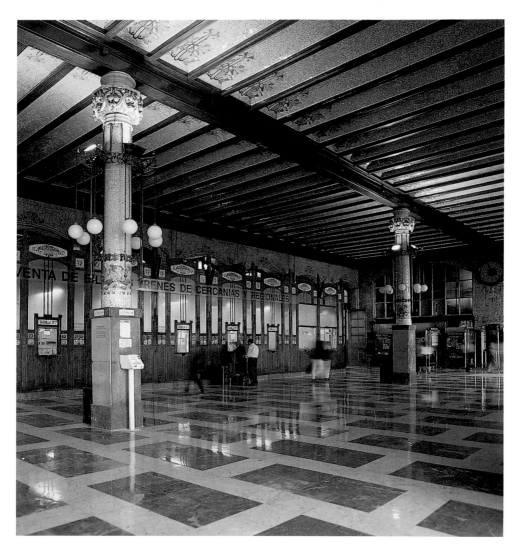

♦ *The exquisite hall is a mix of modernist elegance and Mediterranean sensuality*

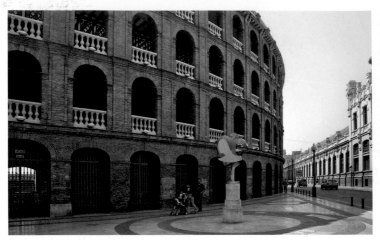

La Plaza de Toros

Immediately adjacent to the station, the Plaza de Toros, established much earlier, in 1860, being a fine neoclassic structure which brings to mind the structure and layout of roman coliseums. Four floors of arcaded galleries, 384 external arches of identical size and shape, this building is, in effect, a perfect brick built circular structure. This was one of the first constructions in the city to use iron in a visible form, in this case it was in the columns which support the upper terraced galleries. The best bullfights are to be seen during the Fallas and the Feria de Julio.

Originally built in the slum district, the Plaza was opened up before the wall was demolished. Now the square forms part of the city's urban and commerical centre.

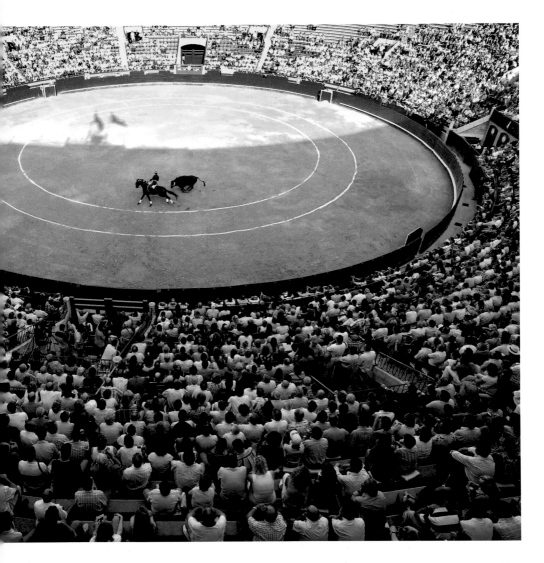

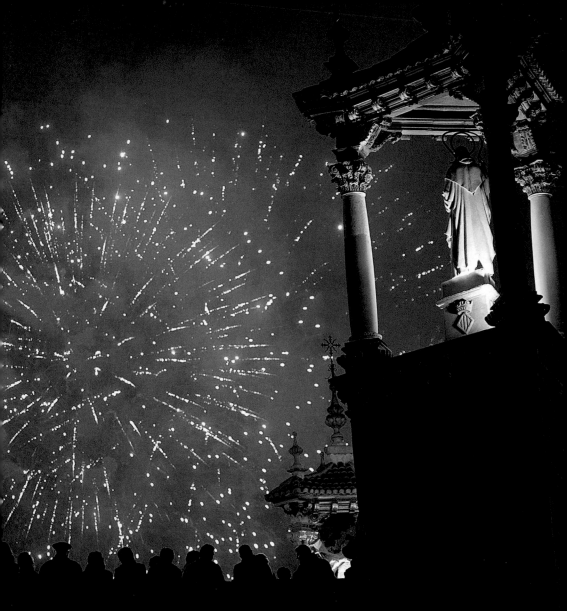

Valencia at fiesta time

The passion for fire is expressed with great enthusiasm at Valencian fiestas, practically with the same voracity shared by its closest manifestation: fireworks. The New Year is welcomed by the heat of bonfires in order to be freed of bad spirits on this the day of San Antonio Abad, the Fallas ritual is totally consumed by fire and fireworks, the Moors lose their fiesta battles against the Christians with the roar of fireworks and San Juan is celebrated with bonfires on the beach.

For the people of Valencia, the fiesta is a popular, extroverted, street scenario, a parade of regional costumes, fancy dress and traditional outfits, all to be seen and admired in street processions, the fiesta being a place to encounter neighbours and visitors, each of which displays not what they are but how they would like to be and what they would like to have. The scene is permanently filled with the sound of the pasadoble and other popular music. The fiesta is understood to be a party venue and a fantasy version of the reality of everyday life.

Another part of the history behind and main element of the fiesta focuses on religion. The public festivities which take place emphasise the power of liturgy, in the knowledge of the rites which permit the most distant to be experienced through that which is closest and the most celestial through the most earthly, the religious representation transformed into a theatrical setting with celebrities, fancy dress and floats.

Valencia at fiesta time is another, somewhat animated means of getting to know this city and its people. These traditions are by no means rooted in decrees or by-laws, it is, on the contrary, the neighbourhood's will and determination which is continually expressed in the re-enactment of their festive rites.

Corpus Christi

The Corpus Christi procession is one of the city's most deeply rooted traditions, creating a bond between former times and artisan trades as well as civil and ecclesiastical powers. Both the powers that be and the public share the same admiration for the carnival like procession with its characters from the Old and New Testament, seen in true Mediterranean style amongst dancing giants and cabezudos, dwarf like figures with large papier-mâché heads.

Before the evening procession created in 1355 passed through las Rocas, triumphal floats of baroque origin which served as mobile stages to depict biblical scenes which were dedicated to King Herod, Adam and Eve and Saint Christopher. The evening procession is brought up at the rear by the custodia followed by the solemn music of grenadiers.

But prior to this the gigantic statues and giant-headed cabezudos will have carried out their slow procession and dancing movements. Next come the eagles, followed by bearers of the huge cirialots or processional candlesticks, the impressive king and queen bearing the city's standard and the most famous biblical characters of the Sacred Scriptures.

One of the most disturbing representations of this Eucharistic tradition is that of the moma, a man completely dressed in white with a skirt and mask which represents virtue, surrounded by other men in black masks, coloured suits and wooden batons, representing the embodiment of the capital sins.

La Tarasca, one of the elements of traditional bestiary of the Corpus Christi of Valencia

Evening procession

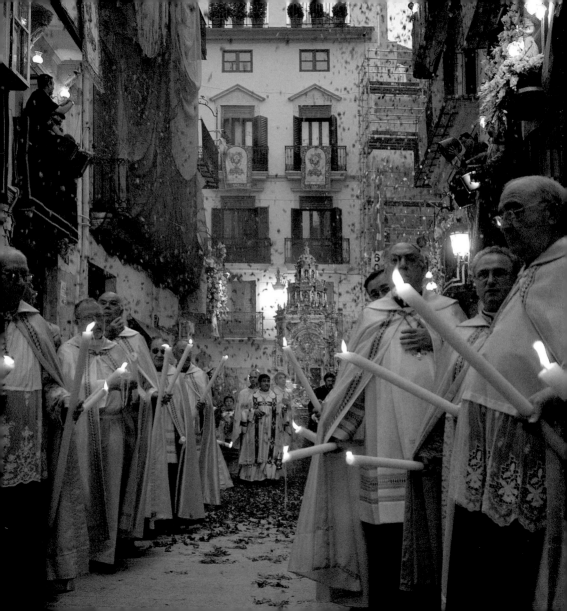

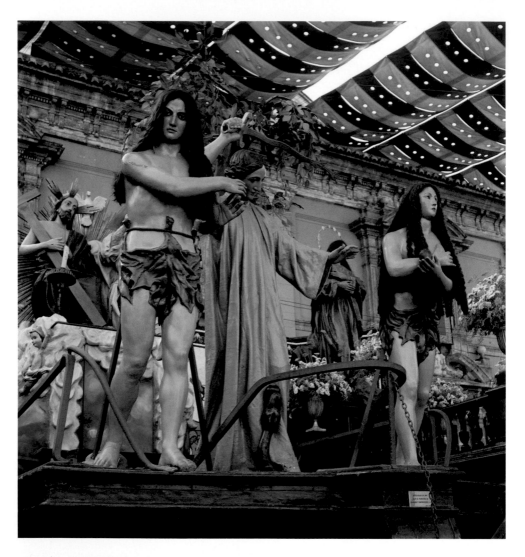

160 *"Roca" of the Holy Trinity, from 1674, with the figures of Adam and Eve in the foreground*

The procession leaves the Cathedral to work its way through the typically narrow streets of the historic centre, filled with the exquisite aroma of flowers, wax, incense and myrrh. On the eve of the festival there is a procession which alludes to La Degollà, the slaughter of innocent children in Jerusalem on Herod's orders. The masked entourage demonstrates the church's involvement in this tradition, its customary dramatised contribution delivering the biblical message. Those in the procession provoke the public who in turn throw water over them.

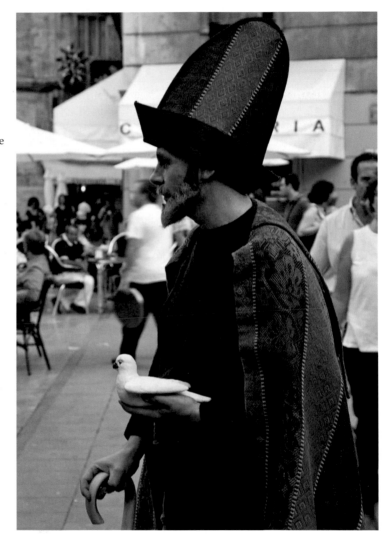

♦ *Valencia's people also played a part in introducing the Eucharistic cult*

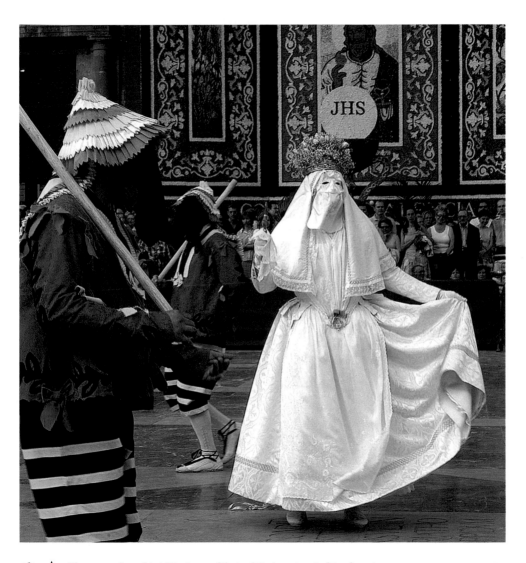

163 ♦ *The* moma, *dressed in white, is one of the tradition's most perturbing characters*

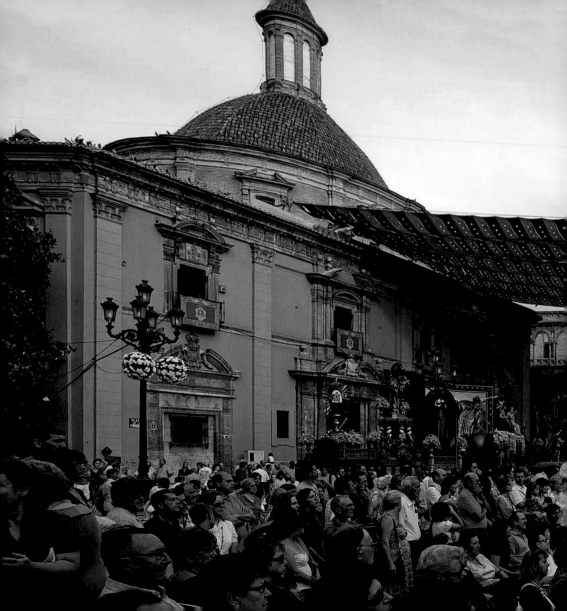

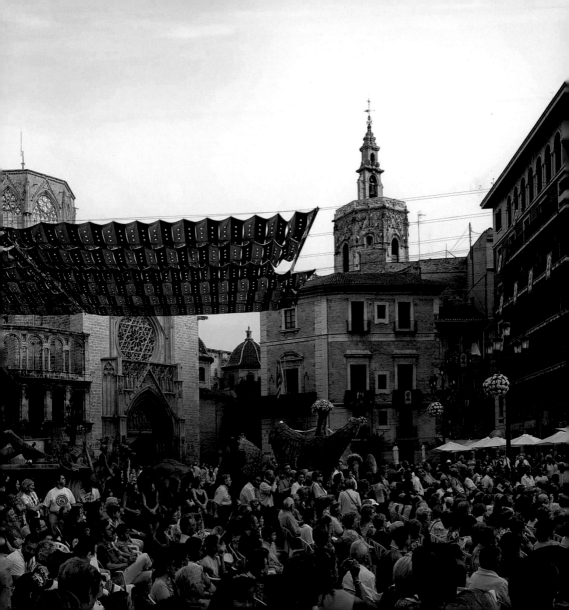

Semana Santa Marinera

Valencian culture is not given to celebrate the most transcendent aspects of life. The most distant, if it exists, is discovered in that which is nearest. The most important is to live for today and not be thinking of the future nor be stuck in the past. The inclination to party, the taste for short-lived moments, the fondness for dressing up and making noise are what makes the festive spirit of these people stand out from others. For this reason Semana Santa Marinera or Mariner's Holy Week, celebrated only in the city's seafaring districts, accentuates the most baroque aspects of religious liturgy and the most theatrical facet of the Passion and the Resurrection of Christ.

The 28 cofradias and hermandades, or brotherhoods and sisterhoods of the Junta Mayor are the true protagonists of this festival which extends throughout the long narrow streets, on a parallel to the sea, in Cabañal and Canyamelar, location of the four parish churches which keep this tradition alive. (Nuestra Señora de los Ángeles, Cristo Redentor, Nuestra Señora del Rosario and Santa María del Mar)

One of the festival's most important days is Maundy Thursday. During the afternoon the monuments are visited en mass and various processions take place including that of the Encuentro, that of the Antorchas supported by the Pretorians and the penitents and finally that of Silencio. On Good Friday, Christ, the patron saint of Cabañal makes an early morning appearance to join in the beach entourage by the light of the rising sun. Shortly after an encounter between the different Christs comes about when the various cofradías or brotherhoods gather on the sea shore to pray for world peace. In the afternoon the cofradías attend the Entierro or burial and the highly respected mourning process which lasts for around six hours. The joy of the Resurrection on Easter Sunday transforms the mourning attire into colourful apparel and the hooded Nazarenes into biblical characters, with female Bible characters much in evidence and virgins represented by young girls.

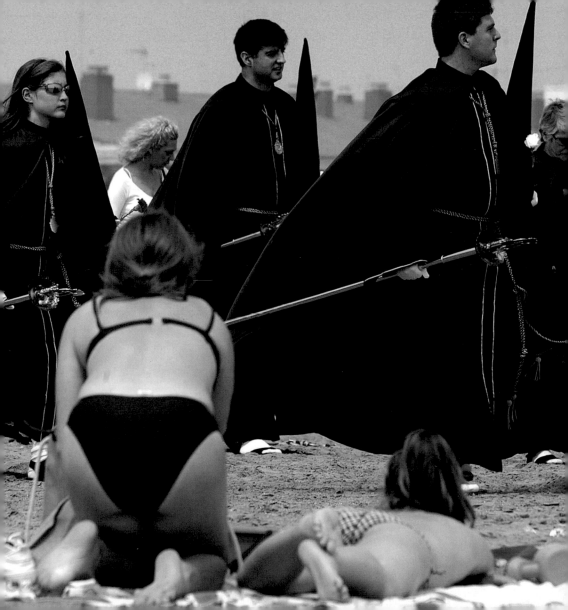

Las Fallas

The Fallas fiesta, originally a means of paying homage to the arrival of springtime by burning all the old to make way for the new, has now become a monumental fiesta in which everything in it is of enormous dimensions, the city's traffic paralysed for days and its streets filled with thousands of visitors awaiting the experience of a lifetime. The fiesta lives in the street, beneath the clear starlit sky or in the plaza beneath the hot sun, all accompanied by the continuous crush of thousands of people.

The Fallas officially begins on the 1st of March and finishes on the 19th, rather like summoning the presence of the almighty sun to fertilise the products of the earth with its heat and light. This fire is filled with giant figures the size of trees which use this source of heat to be transformed into something new. This ritual is a triumph over death and the confirmation of the new life which is brought to nature through the warmth of springtime.

The falla figure always has a story to tell, often told in stages and written on explanatory cartels and also in the llibret, the catalogued contents of the falla. Rather like a motionless comedy sketch, a static dramatisation in which only the story moves not the characters. The chosen themes, of a satirical nature, remain faithful to tradition, exalted in the words of Dionysus and accompanied by his divine entourage. In addition to this sharp-witted hu-

The Fallas always have a tale to tell

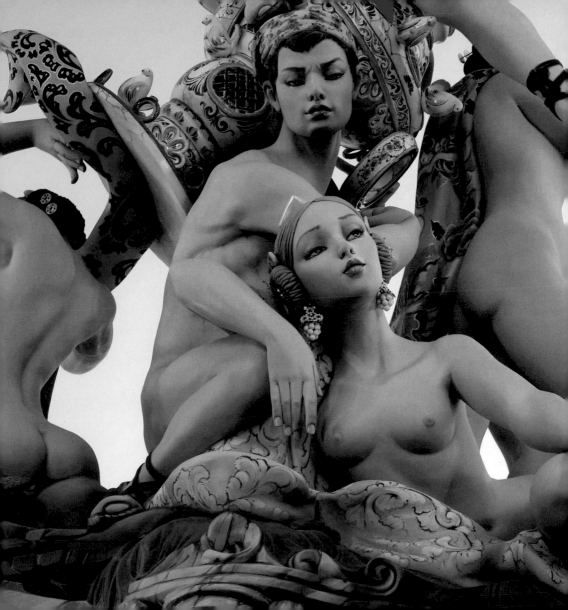

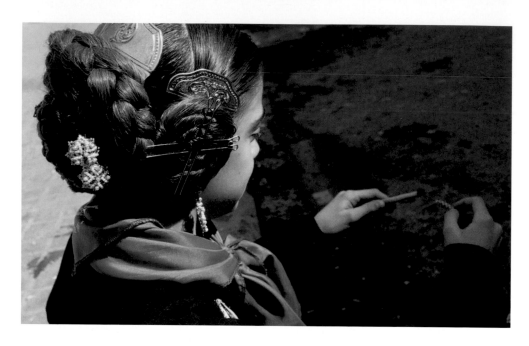

mour the falleros are also used as a means of criticising the city, the district, political life and social customs. In reality the right to criticise is exercised freely for some days until, after the redeeming fire, the established order is to a large extent accepted just as freely.

This is very much a participation fiesta, the construction of the figures and the events which take place are traditionally voluntary contributions by the local neighbourhoods, that is, except for the Plaza del Ayuntamiento falla, financed from the municipal budget. The falleras committee, of which there only remains around four hundred in the city, mobilise thousands of people, dressed in local costumes, who parade the streets to the sound of band music. This is therefore not only a participation event for the visitor but also, in a very special way, for the residents who practice the festive gathering all year round. Each committee has its fallera major, or festival

At midday the plaza del Ayuntamiento plays host to the great mascletá pyrotechnics display

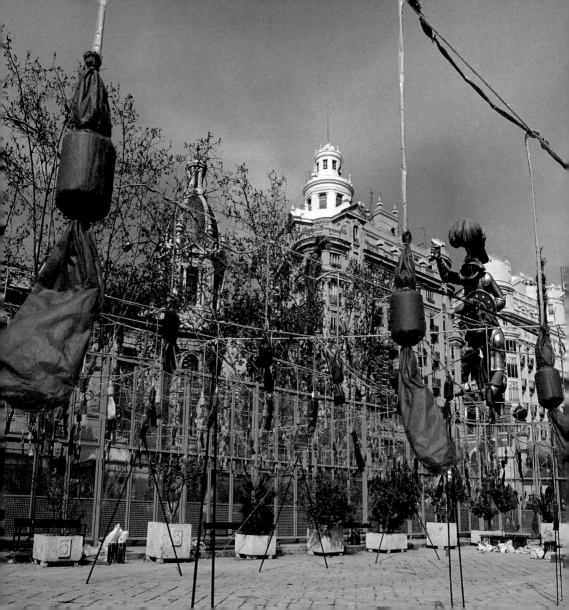

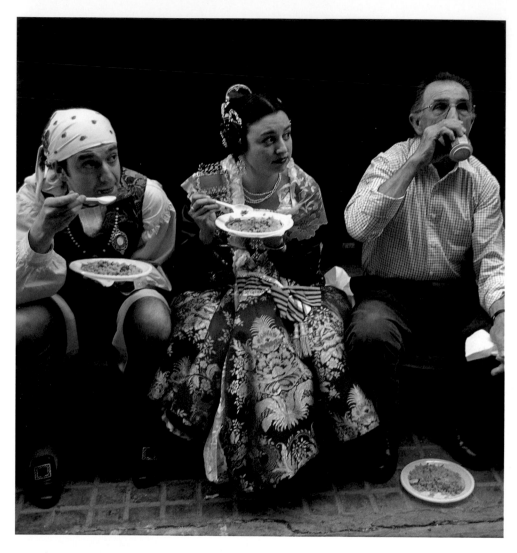

174 ♦ *Paella cooking competitions, held in the middle of the street, result in improvised pavement dining*

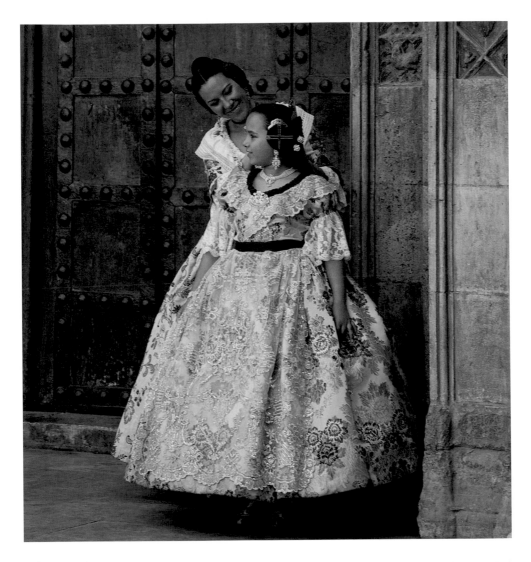

queen, president, treasurer and others responsible for the difficult task of organising the festival.

The figures whose final destination is to be that of disappearing into the flames, are the result of an entire year's work. The falleros artist's guild constitutes the main source of labour with their traditional craftsmanship which has become an industry in its own right and which guarantees many employment. The art of pyrotechnics is also one of the most deeply rooted traditions in this land, seen at its most spectacular during the Fallas. Until the 14th century it was called Greek fire which leaves no doubts as to its origins. Towns within Valencia's metropolitan area such as Bétera, Godella and Moncada have a long history of family dynasties which have transformed this activity into an art and a trade.

Another of the activities which generates work relates to that of making the costumes for the falleras and falleros, the men and women taking part in the fiesta, and the eye-catching headdresses worn by the women. Clearly influenced by the Iberian Dama de Elche, Valencian ladies decorate their heads with decorative golden combs, one to each side and one on the back.

The design and details of the fallas figures remains something of a mystery until on the 15th of March, the night of the big fallas and the day before the children's procession, they finally appear on the street. The following morning they are reviewed by a panel of judges which makes the verdict as to which are the best in the various categories and according to the budget invested in their construction. The most monumental and most costly fallas are placed in a special section apart.

Prior to this, during the ninot exhibition, it will have been decided by popular vote which fallas sculpture or sculptural group is to be pardoned from the fire this year and will alternatively swell the ranks of those preserved for their artistic appeal in the Museo Fallero.

Between the 16th and 19th of March, día de San José many of the city's streets are closed to traffic to make way for the giant fallas and the marquee where the committee's internal procedures take place. The day begins with the wake up call, an event in which the falleros wake the entire neighbourhood with the din of firecrackers and music. Later numerous street parades

The Fallas

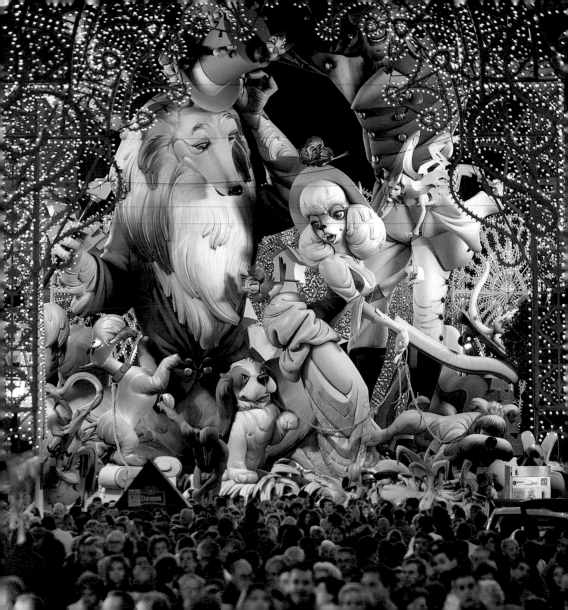

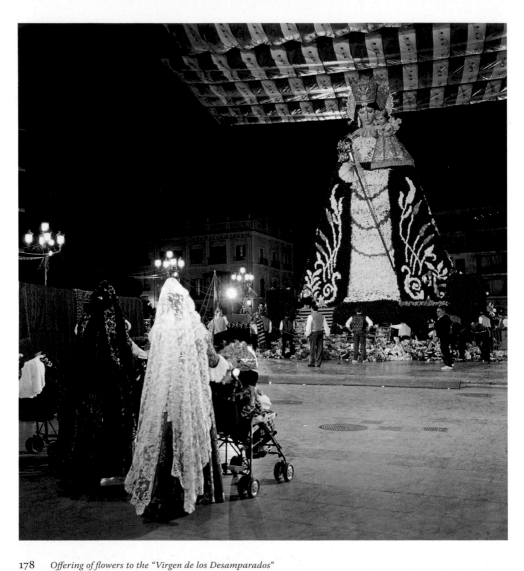

178 *Offering of flowers to the "Virgen de los Desamparados"*

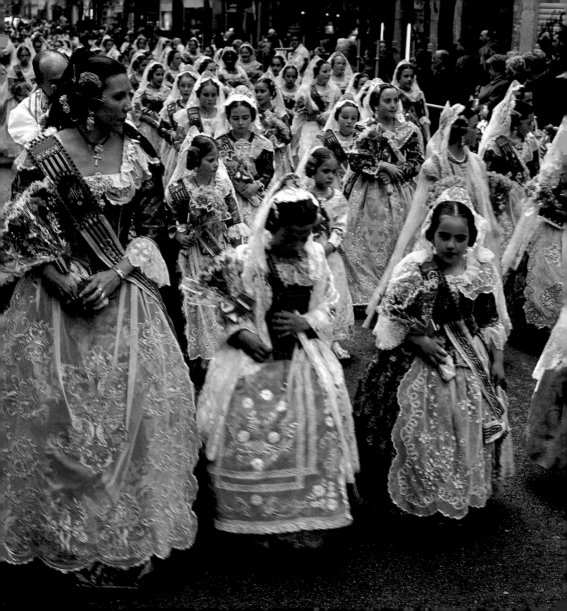

take place and the subsequent prize giving ceremony. Round about midday, between one and two, passions are raised by the thunderous roar of the mascletá as it is fired. This firing ritual begins on the 1st March in the triangular Plaza del Ayuntamiento. Thousands of people turn up at this time, having walked to the city's main square to tremble with the sound of the explosion. The procedure which lasts about six minutes is subject to certain restrictions specified by the fiesta's organisers: it is prohibited for this acoustic attack to be in excess of 115 decibels and no more than 120 kilos of gunpowder must be set alight.

Popular dishes are served by day and by night in the casal fallero, being the social establishment appertaining to each committee, particularly popular are paellas cooked by fires lit in the street itself. On the evenings of the 17th and 18th the offering of flowers is made to the Virgen de los Desamparados and everyone joins in the street parties and other events, the day finally coming to an end with a spectacular firework display. The Nit del Foc is the big event on the night of the 18th when people gather in what was once the old Turia river bed to watch the huge firework display which illuminates the city with monumental multicoloured Palm trees. The neighbourhoods are alive with the raucous sound of dancing and concerts allowing no one to sleep until well into the early hours.

Midnight on the 19th and the fiesta's finale finally arrives with la cremá. The ceremonial burning of the fallero figures amidst huge wooden frames and multicoloured traces of gunpowder until every last trace of the fiesta is eliminated. In just a few hours however, thanks to the city's cleaning department and fire service, there remains not a single vestige of the previous days extraordinary events. The result of a whole year's effort has once more fulfilled its purpose, the old has been banished to make way for the new, yet to be born.

A river of culture

In the words of the somewhat flamboyant expression "a river of culture" a new urban route has been established in Valencia which takes in the most notable of those areas representing the city's cultural facilities. The route in effect covers the same course as the old river, now the aforementioned attractive green zones and sports facilities.

Starting at the furthest point from the coast, here the visitor can if they wish begin by stepping into the Museo de Historia, opposite the parque de cabecera, actually located inside what was the city's former water deposit. The origins of Valencia and the city's major changes are all to be discovered here by means of the latest generation audiovisual equipment.

The Puente de las Artes was given this name because of its proximity to the city's most internationally renowned exhibition sites. The Instituto Valenciano del Arte Moderno (IVAM) which, since its inauguration, has become the world centre for 20th century art. Built by Valencian architects Emilio Giménez and Carlos Salvadores, this art centre hosts a permanent collection of more than 7,000 artworks and 2,000 photographs which very eloquently illustrate the European avant-gardes of the 20th century.

The adjacent Centro Cultural de La Beneficencia, depending on the province's governing body, is dedicated to ethnology, prehistory and traditional cultures. The Centro del Carmen on the other hand intends to rejoin the 19th century museum after many years committed to the most innovative of contemporary art.

Amongst this list of cultural infrastructures we mustn't forget the Casa Museo of painter and sculptor José Benlliure, being a key feature in the urban scenery. The painter's house as well as the garden and the studio are an example of architectural renovation work carried out on the limit of Valencia's former walled city.

Another explanatory vantage point, on the left bank of the old river bed, corresponds to the medieval and modern art of the Museo de Bellas Artes San Pío V. Being something akin to a national art gallery means that this fluvial tour provides a complete picture throughout the differ-

The puente del Mar also provides the pedestrian with some convenient stone bench seating built into the parapets which are also adorned with memorials to saints, as well as decorative pyramids and orbs

ent periods in the world's history of art. This traditional museum boasts a precious blue cupola inside and out and reveals the maestros who painted the most exquisite gilt finished gothic panels during the City's golden age in the 15th century, also exhibited are works by Juan de Juanes, Ribera, Velázquez, Goya, Pinazo and Sorolla, amongst others.

Children are like dwarfs in Gulliver's park

To hear the cultured sound of music, the people of Valencia have a choice of two auditoriums raised precisely within this river of culture. Firstly the public Palau de la Música, headquarters of the Orquesta de Valencia, which operates seasonal programmes with large orchestras and musical interpretations associated with the great names in national and international music. The music hall was constructed by architect José María García de Paredes and opened in 1987. Secondly, run by Valencia's local governing body is the Palau de les Arts, the repertoire of which includes a regular musical season, large orchestral performances and complimentary ballet and theatre programmes.

The cultural zone most favoured by children is parque Gulliver. The children appear dwarfs when sliding down his enormous arms and legs to be transformed into giants once on his insides, gazing at the miniature reproduction of Valencia. This 296 square metre sculpture, designed by fallero artist Manolo Martin, was inspired by the character portrayed by writer Jonathan Swift.

The tour of the new river of culture is bought to an end as it began, with the history of the city. The Museo Fallero is a demonstration of fine arts applied to popular creativity. Located in the Padres Paules ancient monastery is the collection of ninots (papier mache sculptures) which each year are spared from the fires..

This river of culture is complemented by various cultural vessels installed in gothic, barroque and neoclassic style buildings no longer used for the their original purpose.

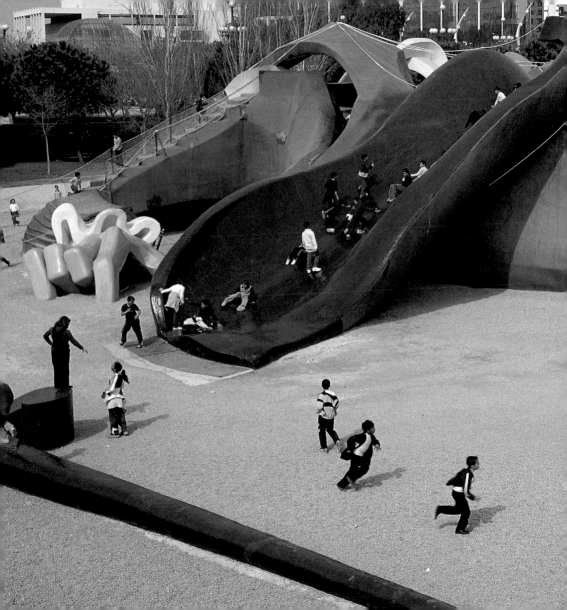

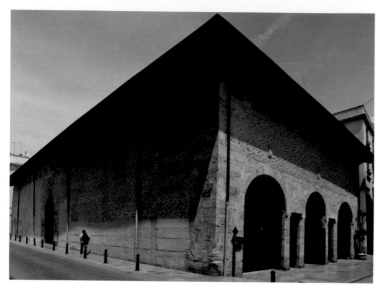

El Almudín was built in the 13th century, over an Arab fortress

Late Romanesque and the most select examples of gothic architecture can be seen in all their splendour in the El Almudín and the ancient Atarazanas or shipyards in the port, both centres designed to be used for temporary exhibitions. The five rectangular construction bays now constitute a display of gothic art constructed to meet the needs of fishermen and tradesmen to accommodate and construct their vessels. El Almudín, a beautiful early 13th century building was erected above an Arabic fortress for the purpose of storing wheat.

The Monasterio de San Miguel de los Reyes represents far more than an exhibition centre. This is the official main site of the Biblioteca Valenciana or library, a tribute to the cultural will deployed between these walls by the viceroys of Valencia, doña Germana de Foix and the Duque de Calabria. It was constructed on the site of an old abbey in the 16th century as part of a renaissance project by Covarrubias, whose constructions always bore the influence of El Escorial. The building has a simple cloister surrounded by an

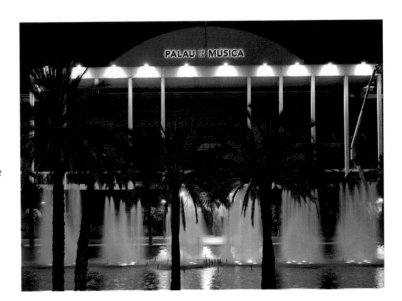

Neoclassical gardens lie at the foot of the Palau de la Música

arched gallery. Once the monastery's prime intention had been taken care of, that of preserving the viceroy's books and mortal remains, it was converted firstly into a sanctuary and later into a prison. Having escaped destruction, it is now a privileged cultural centre located on the outskirts of the city and a permanent link with the city's past.

With slightly less monarchist pretensions and located at the very heart of this historic city is the Convento del Carmen, the former site of the Museo de Bellas Artes and, until the end of the seventies, also the Escuela de Bellas Artes. Its gothic, renaissance, baroque and neoclassic structure also represents art throughout the ages. Firstly it was transformed by the IVAM into their second centre, to purposely illustrate the most youthful and kitschy of plastics designers. This radical dialogue between the traditional and the modern has been somewhat muted by the centre's quest to specialise in Valencian art from the 19th and early 20th centuries.

The list of buildings used for cultural means which have their roots firmly anchored in the city's past continues with the Centre Cultural de La Nau and the Palacio del Marqués de Dos Aguas. The neoclassic centre of La Nau houses the genesis of Valencia's first university established 500 years ago. The statue of humanist Luis Vives, firmly anchored in the centre of the cloisters, represents the European projection of Valencian culture, as he was persecuted by the Inquisition and forced to flee this land and went to France and England to develop his career in philosophy beneath the shadow of Erasmus. Very close to this university site, the luxurious baroque structure of the Palacio del Marqués de Dos Aguas attracts numerous visitors, this being one of their favourite sites.

MUVIM (Museum of Illustration and Modernity) is under local provincial management, constructed by Guillermo Vázquez Consuegra and inaugurated in July 2001, the Palau de les Arts Reina Sofía was the work of Santiago Calatrava and inaugurated in October 2005, the two represent the latest art and music additions to Valencia's cultural offer, the infrastructure of which also includes the scenic arts and cinema as befits this large cosmopolitan European city.

The cupola on the Museo San Pio V Museum, representing the firmament or celestial dome

The San Pio V Museum displays the finest gothic panels in Valencia

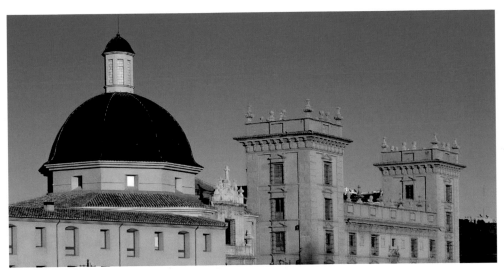

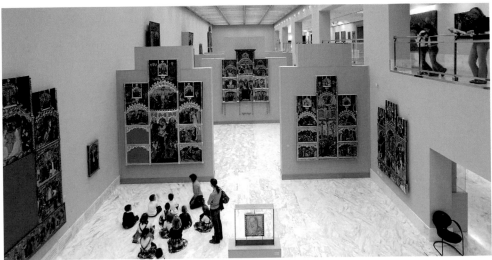

191

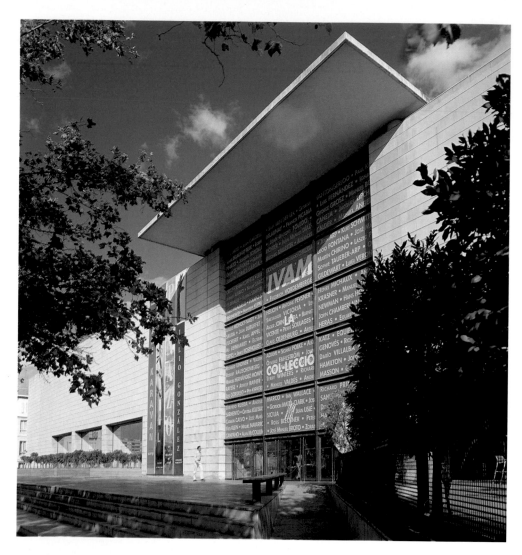

192 *The main façade of the Centro Julio González at IVAM*

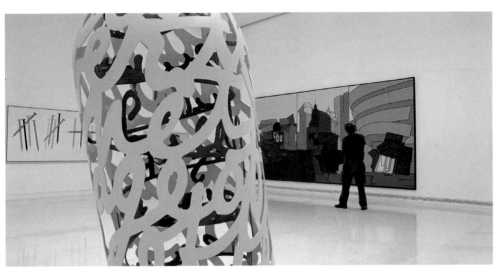

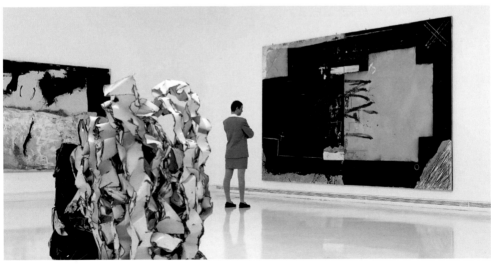

◉ *All the avante-garde artists are represented in these halls*

Bridges

The twenty odd bridges connecting one or other side of the city come in very different styles. After the most highly prized, those of gothic and renaissance origin, almost a dozen were constructed after 1960 and finally six more raised in recent years under the pretence of absorbing traffic.

From east to west, the first modern bridge, Nou d'Octubre, was one of the first contributions to Valencia's renovation to come from architect Santiago Calatrava. The next consisted of a project to extend the city's avenues. The Puente San José is refereed to as traditional architecture, as is that of the Serranos. The Pont de Fusta constitutes a very busy footbridge and the Puente de la Trinidad is also classed as somewhat traditional. Considered to be the most prestigious over the years was that of the Real, constructed in the 13th century and which provided the monarchy with direct access to the heart of the city from their official palace built outside the city walls.

The list continues with a recent contribution by Calatrava called the Puente de la Exposición, more commonly know as "la peineta" referring to the decorative hair combs worn by the falleras, the women who take part in the Fallas fiesta and the Puente de las Flores, a truly costly high maintenance luxury, adorned as it is with thousands of flowers, replaced with each season, which lays claim to this city's love of the floral arts.

*Detail of the
Las Flores bridge*

*View of the spectacular
puente de la Exposición or
Exhibition Bridge, the work
of Santiago Calatrava*

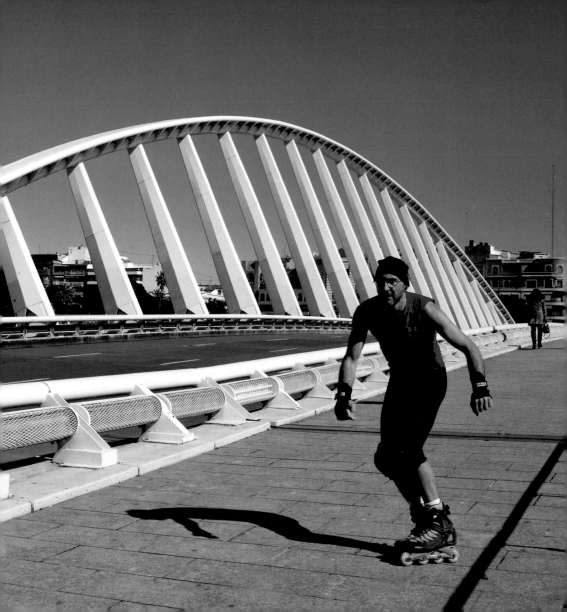

"Demon" on the Reino de Valencia bridge

The original puente del Mar was destroyed by a flood in the 15th century but providing indispensable access to the port area meant the bridge had to be rebuilt fairly quickly. It is only in recent decades the elaborate staircase has been added and the bridge converted to a footbridge

The Puente del Mar was on the old road leading to the port. Now purely for pedestrian use, it rises above neoclassic gardens to reveal one of the most attractive spots along the renovated river bed. The Puente de Aragón is on the road which now leads to the coast although not the only one, there also being the Puente del Ángel Custodio and that of the Reino de Valencia, The latter as a result of civil works is now an updated form of renaissance and art deco architecture. Referred to as the "devils" bridge on account of the fallen angels which in true gothic style appear as gargoyles on its four corners.

The Monteolivete bridge constitutes an esteemed balcony to dioscover the city, while the new L'Assut de l'Or bridge, within the complex, has been produced by the Calatrava studio.

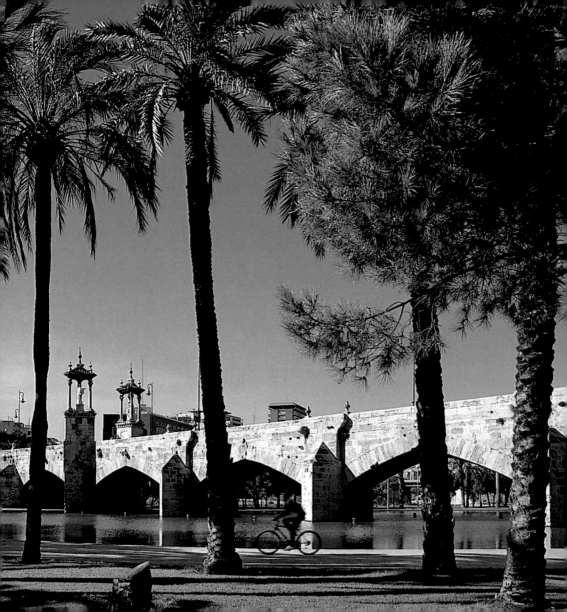

♦ *This sculpture by Valdés is made up of a mosaic of 22.000 small pieces of glazed Iberian stoneware ceramic tiles*

A 21st century city

Valencia, encouraged by the artistic beauty of the Llotja de la Seda, the Micalet and the Palau de la Generalitat, has transformed its formerly gothic and medieval appearance into one which thanks to the powerful presence of various urban concepts which, on the threshold of the 21st century, were marked by certain architects and city planners such as Santiago Calatrava, Norman Foster, Guillermo Vazquez Consuegra, David Chipperfield, Félix Candela, Jean Nouvel, Kazuyo Sejima and Ryue Nishizawa, amongst others. That's not forgetting Ricardo Bofíll, who whilst he only intervened in the fluvial surroundings of the Palau de la Música, he was the first architect, albeit some time before, to come up the idea of creating the Turia gardens. Driven by the new millennium the city was brought new ideas and projects submitted and carried out competing for the future development of this new Valencia in which everything takes place at a fast pace.

The illustrious team of international architects discovered what was to be the starting point for their project from this combination of old and new. The Japanese architects from the Sanaa studio designed the outer skin of the IVAM which evokes of a stroll through Valencia in the shade of the trees to escape the fierce Mediterranean sun and also recreates the special ambience of the inside of gothic churches and modernist markets. Valencian Santiago Calatrava, born within the city's irrigated crop growing area, had only to cast his mind back to when he was a child to bestow a work of art status upon the trencadís, to endow all his constructions with an abundance of water, to create his chromatic profile with white and the subtlety in shadows. Calatrava designed three spiral skyscrapers rather like the gothic columns of La Llotja. Norman Foster focussed mainly on the Mediterranean light and sun. Jean Nouvel rethought the city from the mouth of its dried up river, seeking a new urban estuary to regenerate the coastal section and accentuate the accessibility of its urban beaches.

Current urban growth is influenced by two long lines of pressure, one which extends towards the east and southeast in an attempt to extend the city as far as the sea, transforming the market garden areas into building land after eradicating what was formerly 370,000 square metres of industrial estate. The other growth axis is almost directly opposite heading towards the north and northwest. The modernisation of the Port and the construction of the Ciudad de las Artes y las Ciencias are the main interventions as regards the city approaching the sea to the west and coastal side. El Palacio de Congresos and the inauguration of the new Avenida de las Cortes Valencianas, exercising the same role development wise but in a northerly direction, and what was formerly agricultural land has also been drastically reduced.

The Valencian painter and sculptor Manuel Valdés, resident in New York, has increased the cultural value of the area by erecting an Iberian lady of 20 metres in height on a roundabout which, in the future, will be the entrance to the new stadium of Valencia CF. The lady is made up of 22,000 small Iberian heads of ceramic, coloured in cobalt blue, like the blue that shines and sparkles in the domes of Valencian churches.

The stadium will have a capacity of 75,000, distributed on three tiers designed in an oval and all covered. The main architects correspond to the company of Reid Fenwick Asociados. The project was chosen after a hard-fought contest in November 2006. Work began two years later. Its finalisation will depend on finding the required funding

There remains one more future challenge for Valencia and that is the transformation of the 800,000 square metres of land, currently occupied by the present day estación del Norte railway station and its corresponding railways lines, the area of which will be used to create the much awaited Parque Central. The project will transfer the station underground and thus prevent the present day urban bottlenecks caused in the centre and the south of the city by the constant need for level crossings, tunnels and bridges to cross from one side of the railway lines to the other.

L'Ágora, from the new L'Assut de l'Or bridge

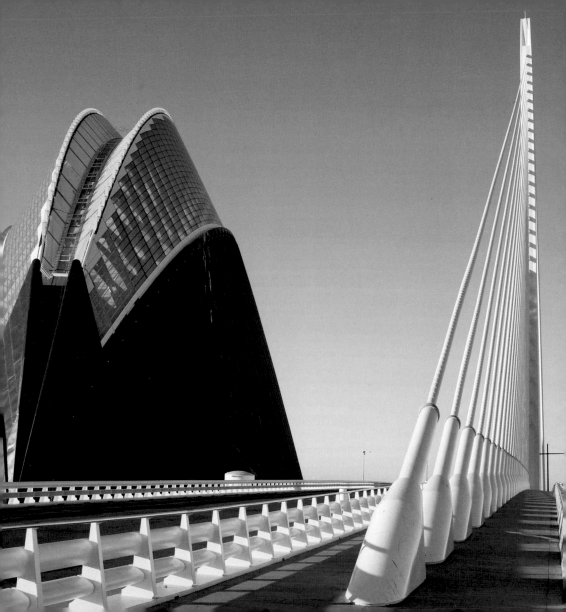

Palau de Congressos

The capital of the Turia is one of the favourite public squares in Spain to hold trade fairs, congresses and conventions. Just in the sphere of industrial and agrarian production and commercial activity, the Feria Valencia venue, close to the Palau de Congressos, a building designed by Norman Foster, offers fifty events each year that bring together one and a half million professionals, representatives of around 12,000 companies. The number of scientific, cultural and political congresses that choose the city as a headquarters is very extensive and interesting. Valencia is a leading centre in biochemical research. For this and other reasons, the City Council has tried to attend to these demands and expectations promoting a new infrastructure, that of Foster, worthy of the 21st century.

The congressional hall, run by the local administration, was designed by the British architect as the motor of growth that Valencia needed in its northern part and also as an illustration of what is his architectural genius applied to the needs of Mediterranean culture. The building, of blatantly horizontal appearance, rises slightly on its façade in order to collect all the light and heat provided by the local climate. Added to the interest and modernity of its interior halls and auditoriums is the attractiveness of the seven thousand square metres of exterior space, with a lake, an impressive rose garden, fountains and large forested area.

The horizontality of the Palau de Congressos contrasts notably with the great height of the new buildings and hotels that fill the Avinguda de les Corts Valencianes, attracted by the presence of Foster's work.

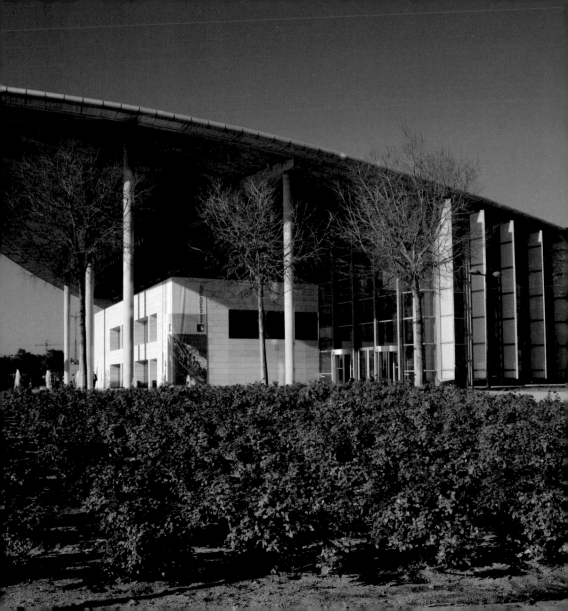

City of Arts and Sciences

This impressive urban and leisure complex that the Generalitat Valenciana promoted as from the early 1990s endeavours to place Valencia in the European selection of cities prepared to speed up the process of modernity. When the architectural intervention took administrative shape and dimension, Valencia had been left outside the big strategic triangle produced in 1992 between Barcelona, Seville and Madrid with the holding of the Olympics, Expo 92 and Madrid European Capital of Culture. The Valencian government, in order to resolve this marginalisation, promoted the Música 92 initiative with the aim of entering into celebrations of an international nature, and at the same time give Calatrava carte blanche to design the Valencian city of the future.

Although the *Ciutat* has had the limited collaboration of other architects, the authorship of the global conception of the project and its realisation corresponds to the Valencian Santiago Calatrava, who has wanted to make clear here the big commitments to the future: science, culture and leisure, experienced in a setting marked by the abundance of water and plant life.

In order of the opening date the first building was the *L'Hemisfèric*, which opened in 1998. Its outer design imitates a massive human eye, which looks on how a lake of 24,000 square metres returns its image reflected in the water. Beneath its semi-spherical pupil is the IMAX film projection hall. The eyelids and lashes, thanks to an intelligent piece of engineering work, move opening or closing.

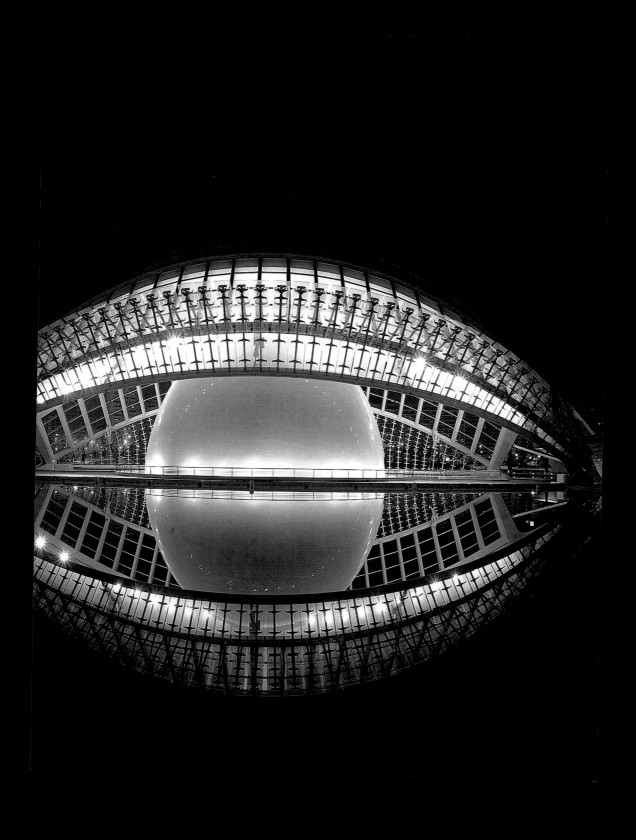

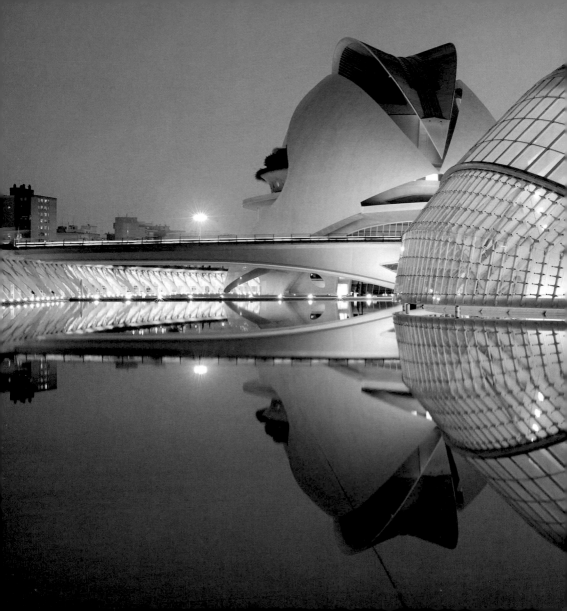

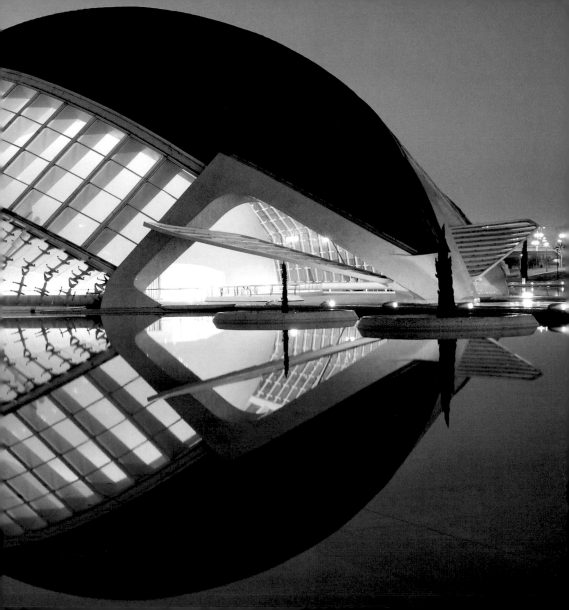

The *Museo de las Ciencias Príncipe Felipe* possesses 42,000 square metres distributed on five floors occupied by many temporary or permanent scientific exhibitions. Large arches that reach up 40 metres give this building the appearance of a skeleton of an impressive diplodocus prepared to house in its entrails the most suggestive didactic games that bring science closer to children and adults alike. The water that surrounds it also allows you to see yourself reflected on the surface of the lake.

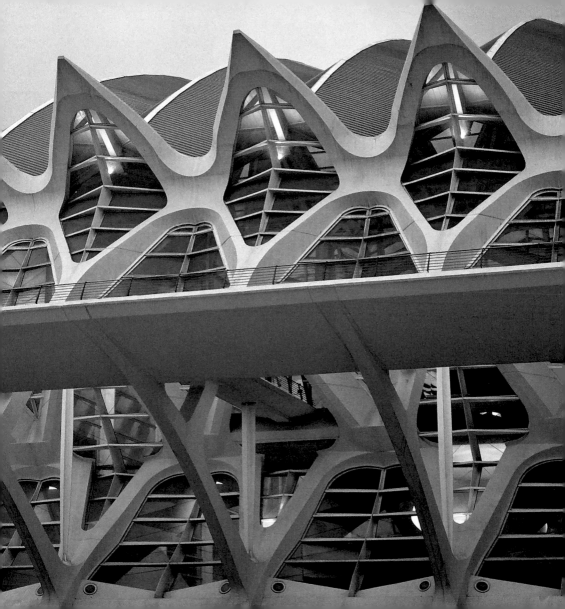

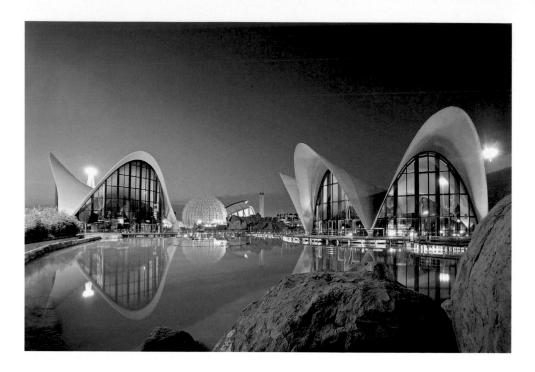

The third unit of the leisure complex is the *Oceanogràfic*, an authentic underwater city created by the architect Félix Candela. It is populated by 45,000 animals, which live in 42 million litres of water. This giant aquarium, the biggest in Europe, is distributed into ten large areas that show the diverse marine ecosystems in the world. It is the most-visited space in the *Ciutat*. The acrobatics that the dolphins perform to welcome new visitors really thrill everyone, just as the Auditorium, the backcloth is the large aquarium of the *Mar Rojo*, arouses great admiration.

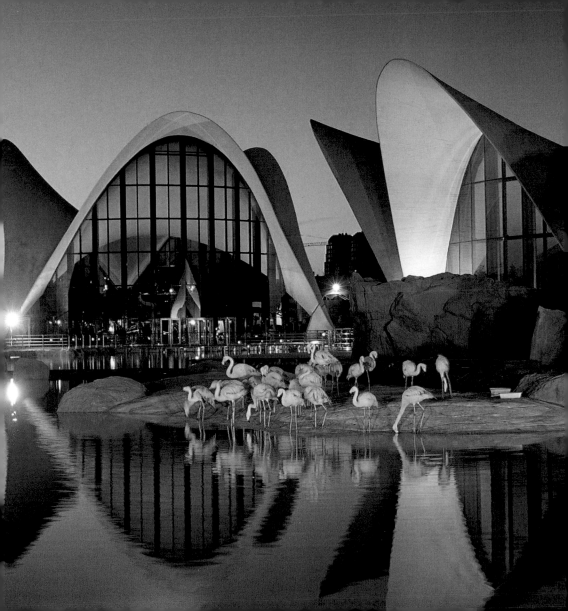

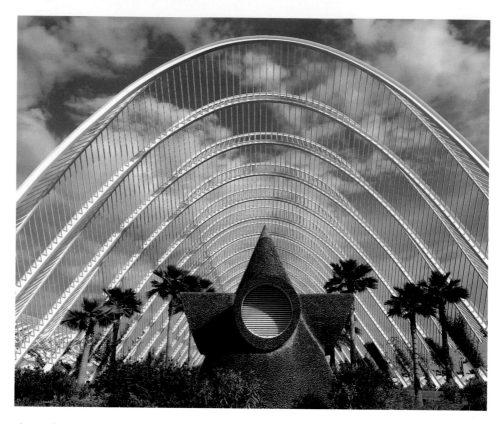

The *Umbracle* represents the entrance porch to the complex built over the car parking area. This green area of 7,000 square metres houses a pathway of sculptures with contributions by Yoko Ono and the Valencian Miquel Navarro, among others.

Umbracle

Palau de les Arts Reina Sofía

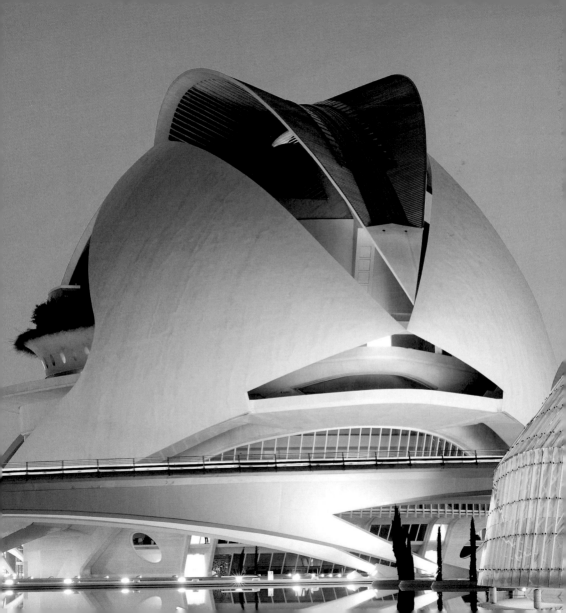

Everything in the *Palau de les Arts Reina Sofía* is grandiose. Situated at the initial head of the leisure complex, it acts as the bow of the vessel run aground in dry dock or probably a gigantic Trojan helmet. In Calatrava's designs it seems that first are the essential forms, the sculptural conception and then the technical development. This auditorium, opened in 2005, is for opera, symphonic music and ballet. It has a capacity to house at any one time 4,000 spectators distributed between the main hall, upper auditorium, master classroom and chamber theatre. Protected beneath a large metallic waterfall, covered in white *trencadís* mosaic, has projecting platforms with walkways and plant ornamentation and large glass-fronted halls to appreciate the outdoor setting.

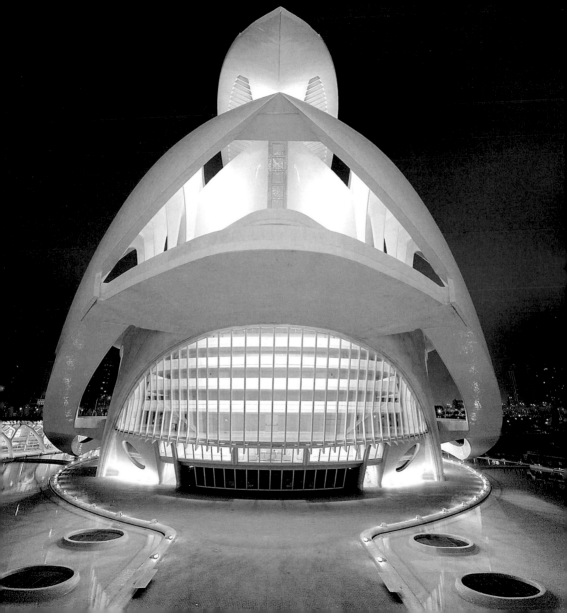

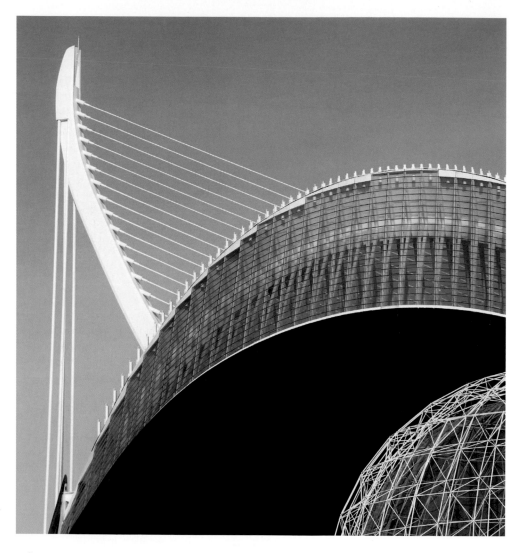

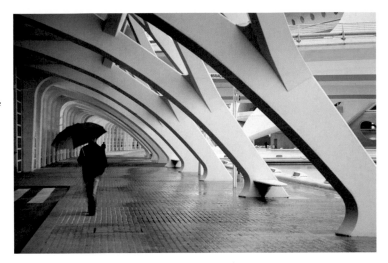

The sixth building of the complex, the *Ágora*, a multi-use building
used for official acts and events, is 70 metres high, and was opened the
with Valencia Open tennis tournament. This building with uncove-
red vertebrate structure, very close to Calatrava's style, possesses two
enormous wings by means of two mobile side roofs. Their covering in
blue trencadís mosaic makes them shine. It represents the symbol of the
flight of peace.

From the platform of the spectacular *Pont de L'Assut de l'Or* one can
take in the final structure of the *Ciudad de las Artes y las Ciencias*. Its
opening has been a great relief for all the traffic of the south boulevard
of the city. The name comes from an old irrigation dam (*assut*), regulator
of the Turia, which stands restored in the area around the bridge. It is
180 metres long and 125 metres high. Its large pole held by 29 cable-
braces forms a very powerful image of this urban complex. The central
pavement enables pedestrians and cyclists to travel along its platform of
six lanes illuminated at night by a suggestive light.

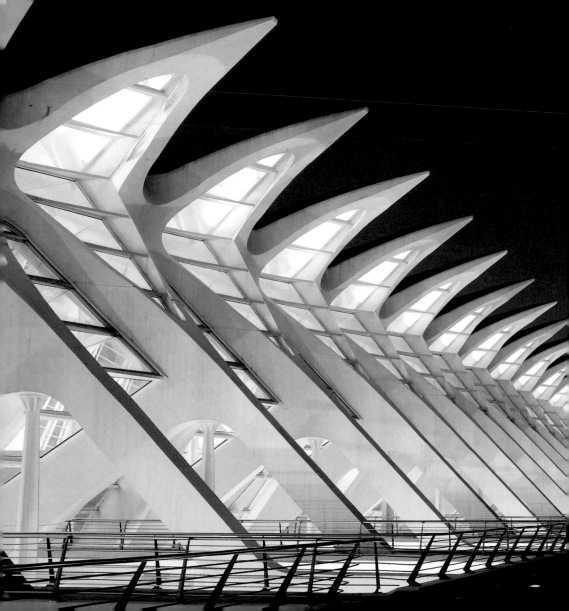

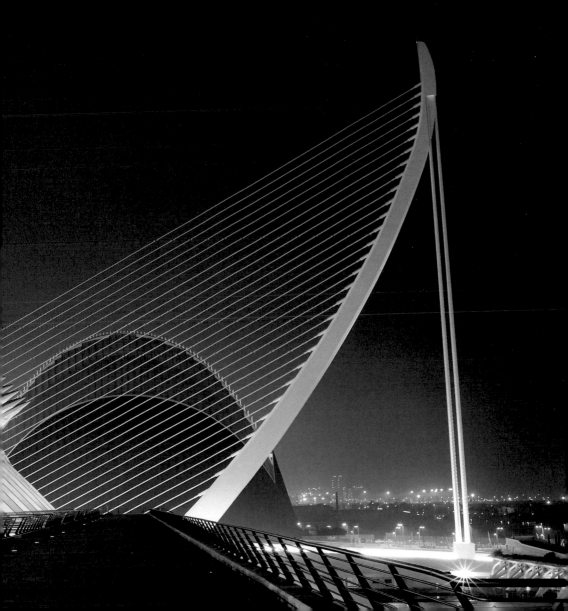

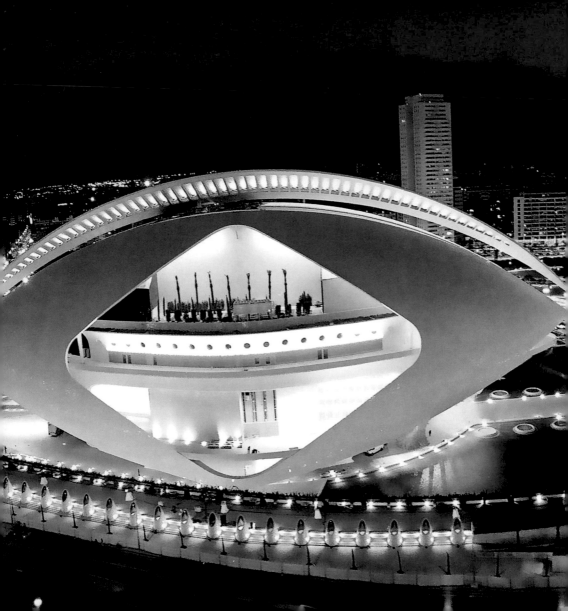

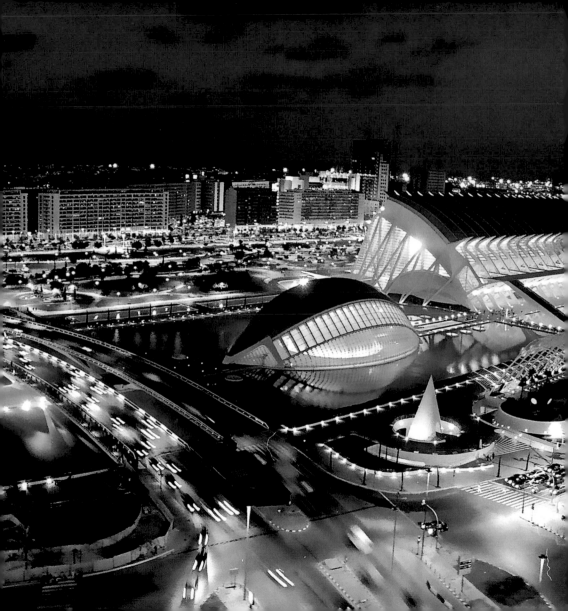

Seafaring Valencia

The city seems to have only discovered the sea in recent years, when in reality the Mediterranean was discovered millenniums ago by the inhabitants of this region through fishing, commerce and territorial expansion. The difference is that now it is possible to find a good hotel on the city's coast and likewise a sophisticated restaurant. In the past any stay here was purely transitory, a few hours in passing. The city dweller appeared before the sea merely to spend the day on the beach and enjoy a paella with the family.

The new Paseo Marítimo, ample beach parking facilities, the refurbished traditional restaurants, the transformation of the former Las Arenas spa into a hotel complex, the extensive renovation of the port's inner docks, the arrival of the metro and the tram, all just some of the vast improvements which have permanently united the coastal suburb with the cosmopolitan city.

This part of the city originally revolved around port activities and fishing. In the fortified town of Grao, ships were constructed and repaired and commercial activities organised. In the Cabañal district, with its long streets parallel to the beach, the fishermen's guilds created a popular and extroverted way of life, very different to the conventional and conservative approach of Valencia's historic centre.

Botanist Cavanilles, wrote, in what was 18th century language, of his remarks on the area: "Grau has a gently sloping fine sandy beach. It is here those from the capital come to bathe, their prodigious competition bringing life to this area, attracted by the movement of the waters and the ships to be spotted. In former times they came and went usually on the same day... Many shared in the spontaneity and entertaining aspect of the situation, usually remaining for some days generally housed in fishermen's huts".

Playa de la Malvarrosa

This is the name given to the beach just north of the port. The name refers to a plant from which the essence is extracted and used in the manufacture of perfume. The area has strong links with the literary traditions of writer and political leader Vicente Blasco Ibáñez and postimpressionist painter Joaquín Sorolla, the reason being that at the onset of the 19th century, as was customary for the local bourgeoisie, they too spent their summer vacation on this beach including many delightful hours of creation before this luminous horizon. Blasco, from the large terrace of his chalet, now a commemorative casa museo, would sit before a marble table flanked by two caryatids, facing the sea, his literary fantasies given absolute free reign.

The wide 35 metre strip of clean sandy accessible beach and the convenience of the long sea front promenade mean the interminable hours of sun and the pleasant evening breeze can be enjoyed to the full, at the best times of the year. The morning sun appears on the horizon above these waters, ready to warm and tan the skin. Sorolla's seascape paintings, inspired by this beach, portray to perfection the heat and colours of Valencia's surrounding coastline.

Playa de la Malvarrosa beach is part of the group of Poblados Marítimos or seaside districts including Nazaret (south of the port), Cabanyal, Canyamelar (a reminder of sugar cane) and Malvarrosa. A stroll along the long straight streets of Cabanyal introduces us to a widespread architecture in which brightly coloured ceramic tiles are mixed with decorative carpentry on doors and windows and some excellent wrought iron work.

The Las Arenas spa, now transformed into a luxurious and spacious hotel complex, was originally a replica of the open sea baths on the French Côte d'Azur which included special areas set aside for women to take the sun without being observed. Another former installation, the Casablanca hot baths, is now a busy nightclub for parties and all manner of celebrations.

Water sculpture on the sea front promenade or Paseo Marítimo in La Malvarrosa

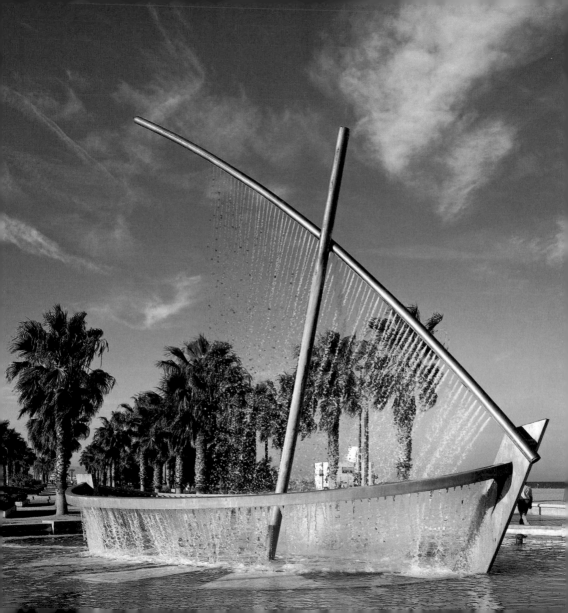

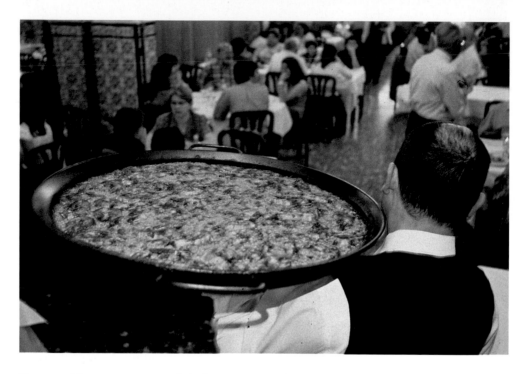

The paseo Neptune or promenade is the gastronomic heart of this area with an excellent choice of restaurants in which to eat either the much sought after paella or fish or Valencias's tasty seafood specialities. Local districts breathe a vibrant air here, reflected also in the many colourful façades, decorated this way to differentiate one house from another.

Valencia's sea front displays a wealth of gastronomic delights

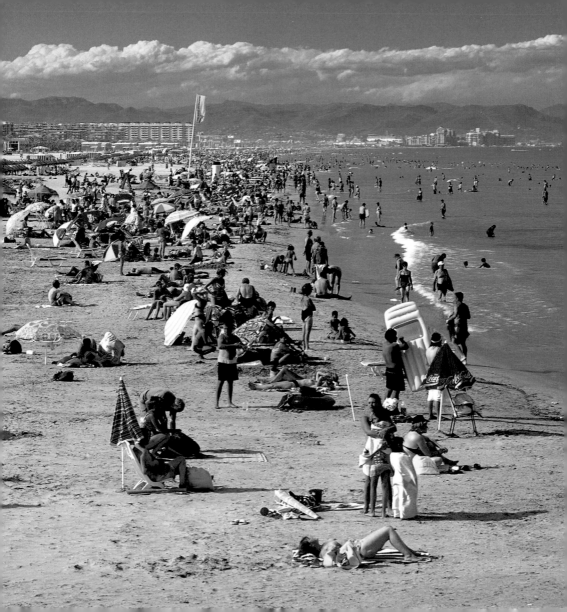

The Port

The Clock building has the potentiality of taking on the role of watchtower of the port, which does not only show the time of day. It is also the most well-known and popular visual icon of the old Valencian port, designed in 1676 by the master builder Tomás Güelda. Thousands of travellers have arrived or departed from the city recording in their memory the image of the old clock; travellers who never imagined that at the feet of the tower, in the early 21st century, Formula 1 racing cars would pass by and the sails unfold of the most sophisticated boats in the world.

This building, with airs of an elegant French pavilion, has at its back, behind some modern buildings protected by arcades, the old Dockyards, a splendid example of Gothic civil architecture, today dedicated to house art exhibitions. Inside are built many commercial ships.

The inner dock of the port, now called Marina Real Juan Carlos I, is occupied by some rehabilitated cargo storage naves built in 1910 in accordance with the rules of Modernism applied to the presence of colourist mosaics and the use of industrial materials. Moreover, the visual testimony of the old cranes recalls the efforts made in loading the holds of the ships. The Modernist architect Demetrio Ribes built commercial docks and Enrique Viedma the Customs building in 1930, situated to the left of the Clock building overlooking the port's waters.

All these architectural testimonies belonging to the city's past have been rediscovered on becoming transformed into the setting for international sporting events. The home ports of the participating teams in the America's Cup, the most important nautical sports event in the world, have been established amid the walls and mosaics of this Modernist architecture and have led to a social, tourist and commercial life unknown in the perimeter of the inner dockyard. On several occasions thousands of spectators have filled the provisionally installed terracing in this urban setting to enjoy close-up the roar of the Formula 1 cars. So, if the clock tower once marked the night-time departure of the boat from the Balearic Islands, today it shows the time to the thousands of daytime and night-time visitors ready to make the most of the sports and leisure complex on dry land.

Clock Tower, the old maritime station

Las Atarazanas, example of civil Gothic architecture

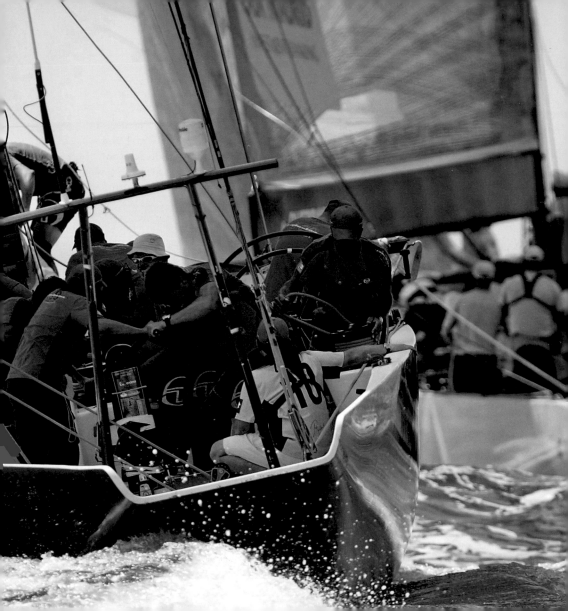

America's Cup and Formula 1

The collective dream of 21st-century Valencia is projected looking towards the port and its Mediterranean waters. If at the turn of the century the city converted its pld river into an attractive park and looked for the way to provide splendour and modernity to its seafront, today all the expectations are focused on the seafaring Valencia, by planning skyscrapers, avenues and residential areas in the old maritime towns. It is the big challenge boosted by the choice of the city as the headquarters for the America's Cup and European Formula 1 races.

The oldest sporting event in the world, which in 2007 was held once again in a European city, after 152 years of English-speaking hegemony, represents an unquestionable media promotion among millions of people round the world. After the 2010 competition, between the American trimaran BMW Oracle and the Swiss catamaran Alinghi, the cup has returned to America with the triumph of the Oracle, although it is not out of the question that the regatta area of Valencia will be chosen again by the winning team, at least for prior testing.

Valencia rivalled another 56 cities to be the headquarters of this competition. Its social dynamism as well as the fair weather tipped the balance in its favour. An average temperature of 17° C, sun practically all year round and the variability of its compass rose marked the ideal nature of its candidacy. In the gulf of Valencia there is always wind. At dawn it starts as a westerly or land wind, later in the morning it veers round north and east, and in the afternoon is a south-east or south-west wind.

This definitive embrace of the historic centre of the city with its coastal façade has enabled the profound transformation of the port. The new Marina Real Juan Carlos I connects its interior dock, the oldest, directly with the sea to avoid the intense commercial and passenger traffic of the port. The sailing boars enter via a canal of 600 metres to the best moorings. The old wharves, with avant-garde designs, which host the headquarters of the America's Cup teams, offer a cosmopolitan and

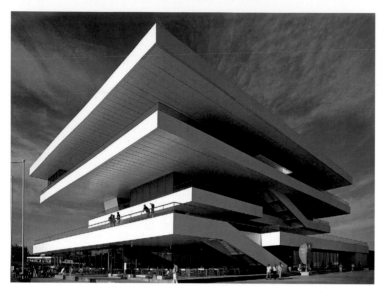

The "Veles i vents"
building by the architect
David Chipperfield

multicoloured panorama. The construction of 700 new moorings for sports boats and a new international press centre, open in the abandoned maritime station, are other interventions resulting from this radical renovation and enlargement of the port.

The guests' building, called "Veles i vents" (sails and winds) is the responsibility of the British architect David Chipperfield, deserved winner of the LEAF 2006 architecture prize. Situated next to the canal it provides a monumental royal box to contemplate the sailing boats in the regatta area. It is made up of horizontal platforms that create shaded areas in different terraces. The name is a homage to the medieval poet Ausìas March, and the Valencian singer Raimon, who put his poems to music.

It should be pointed out that Valencia already had an important seafaring tradition. Very close to the port, in the south part, alongside the new mouth of the River Turia, are the installations of the Real Club Náutico de Valencia, founded in 1903. It measures

In the foreground, the port's modernist style commercial buildings and in the background the Edificio del Reloj, or clock tower which used to be the maritime office where tickets were sold. Now the building is used for exhibitions and acts of protocol

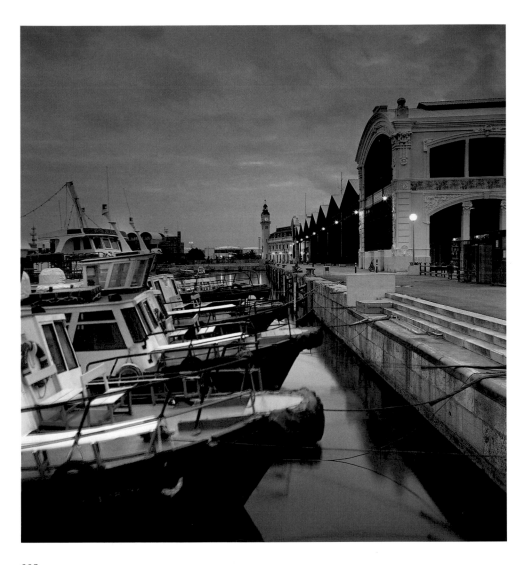

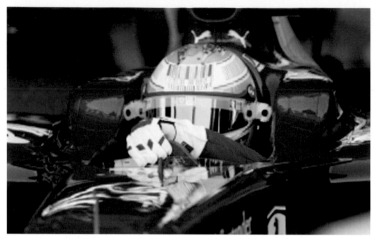

400,000 square metres. Its floating docks house the best cruiser fleets of the Valencia Community.

The pulse of the city also races every time this urban area organises a Formula 1 race. Part of the infrastructures of the nautical event has been converted since 2008, and at least until 2014, in tracks to house the vibrant spectacle of the Grand Prix of Europe. Valencia is one of the few urban circuits in the world that has special boxes placed over sports boats to view the competition from the water. A mobile bridge, symbol of the organisation, joins the two sides of the canal through which the nautical competitors parade. Sail and motor, boats and cars, rudders and wheels go hand in hand in the same urban thanks to world sport.

The Formula 1 urban circuit of Valencia 1, designed by the German Hermann Tilke, is five kilometres and 473 metres long, has 25 bends (11 to the left and 14 to the right) and allow for a race of 57 laps. The starting straight and the boxes are on platform 4 when the race is held. After these days of frenzy, the new sports marine recovers its calm and pleasant pace.

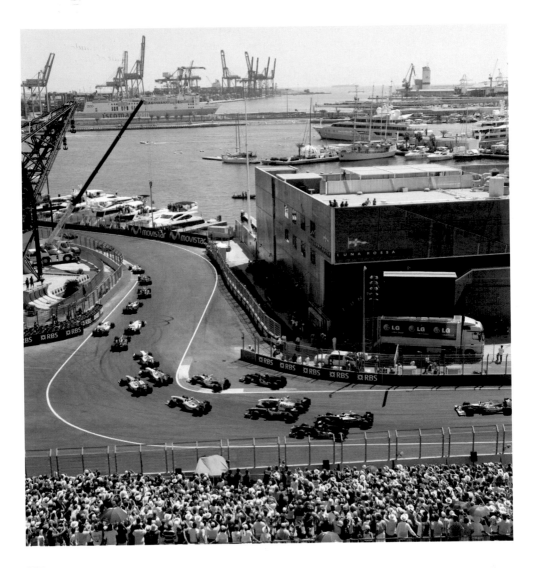